POSTCARD HISTORY SERIES

Early Downtown Los Angeles

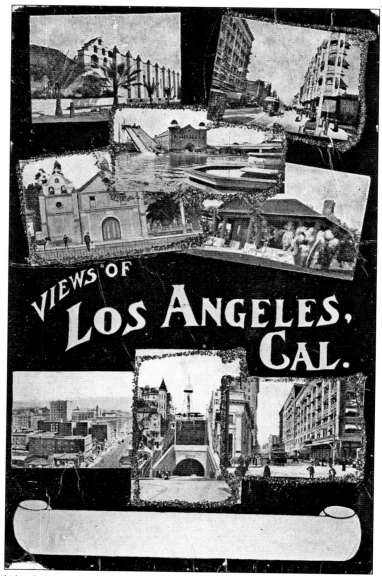

This postcard displays a collage of scenes in early Los Angeles. A variety of downtown sights and attractions are shown, including the Plaza Church, Chute's Park, Angels Flight, several street scenes, and an overview of the skyline and the growing business district. (Cory and Sarah Stargel collection.)

ON THE FRONT COVER: Constructed throughout the 1920s and 1930s, the Los Angeles Civic Center was designed to reflect the city's new metropolitan status. The centerpiece was Los Angeles City Hall, an iconic structure on the downtown skyline since 1928. (Cory and Sarah Stargel collection.)

ON THE BACK COVER: This is an image of Broadway and Ninth Street in 1941. Once located on the outskirts of town, Broadway had developed by the 1920s into the city's main shopping and theater district. (Cory and Sarah Stargel collection.)

POSTCARD HISTORY SERIES

Early Downtown Los Angeles

Cory and Sarah Stargel

ARCADIA
PUBLISHING

Published by Arcadia Publishing
Charleston SC, Chicago IL, Portsmouth NH, San Francisco CA

Printed in the United States of America

Library of Congress Control Number: 2009921929

For all general information contact Arcadia Publishing at:
Telephone 843-853-2070
Fax 843-853-0044
E-mail sales@arcadiapublishing.com
For customer service and orders:
Toll-Free 1-888-313-2665

Visit us on the Internet at www.arcadiapublishing.com

We would like to dedicate this book to Rufus T. Firefly, Chicolini, and Pinky. Without their help, this book would have never been completed.

CONTENTS

ACKNOWLEDGMENTS

We would like to acknowledge the love and support we have received from our friends and family, especially our parents.

We would also like to thank Arcadia Publishing for allowing us to play a role in preserving the wonderful history of Los Angeles.

All of the postcards in this book are from the authors' collection.

INTRODUCTION

When Los Angeles was founded in 1781, the tiny Spanish pueblo consisted of a land grant extending 6 miles in each direction. However, life in the city's early years centered around the Plaza, and the surrounding area, now known as downtown Los Angeles, was considered "out in the country." Throughout the Spanish years and continuing through the Mexican period from 1821 to 1847, the Plaza was the site of the city's social, religious, business, and governing activities. Civic buildings and the town's first small shops were located there, and a fine adobe home on the Plaza was considered a sign of a family's high social status. In the years after the city passed into American hands in 1847, some business activity began to occur just south of the Plaza, while Main Street and San Pedro Street developed by the 1870s into fashionable residential neighborhoods.

Everything would change, however, in 1876, when the Southern Pacific Railroad completed a line south from San Francisco, providing the first connection between the small city and the rest of the country. City business and civic leaders, seeing an opportunity for Los Angeles to take its place among the nation's important cities, fought to secure the city as a railroad stop, offering the Southern Pacific huge incentives to choose a route through the city rather than the easier passage through the Mojave Desert. Their efforts paid off almost immediately, as Eastern settlers began migrating, some seeking the healthful benefits of the sunny Mediterranean climate and others hoping to pursue adventure and new business opportunities. Residential districts grew, churches were established, and new stores, businesses, and banks opened as the city began a steady pace of southward growth.

Despite this new activity, nothing could have prepared the small city for the monumental growth that would occur after 1885, when the Santa Fe Railroad provided a second transcontinental connection. The competition between the two railroads produced a heated rate war, with prices dropping so low that almost anyone could afford to come west. The influx of new residents and tourists set off a massive economic boom and building frenzy, during which the area today encompassing downtown Los Angeles began to be developed with fine hotels, new residential neighborhoods, and increasingly larger shopping and business districts. Even after the boom fizzled out a few years later as a result of hyper-inflated real estate prices, new residents continued to arrive, and the city's course toward metropolitan status had been set.

As the population of Los Angeles skyrocketed over 100,000 by the start of the 20th century, a drastic increase from the less than 2,000 who had resided there in 1850, the downtown business district developed both to the south and the west of the original Plaza area. As banks moved from Main Street, shifting west to new large modern office buildings, Spring Street was soon

established as the city's financial and banking center, becoming known as the Wall Street of the West. Popular retailers also began relocating in the early 1900s, moving from smaller shops on Main and Spring Streets to impressive new department stores constructed on Broadway. When, a few years later, the theater district also began shifting west to Broadway, with both legitimate theaters and movie palaces being constructed, Broadway became the center for both shopping and entertainment.

In the 1920s, business and civic leaders began collaborating on plans for a new civic center. Designed to reflect the city's new prosperity and importance, the civic center included several impressive government buildings and was crowned with a landmark city hall that at 464 feet far exceeded the 150-foot height limit in place since 1906.

As the city changed between the dawn of the 20th century and the 1940s, downtown residential districts all but disappeared, a result of both business expansion and the availability of new suburban housing options. With transportation provided throughout the region by an extensive system of Pacific Electric streetcar lines, the city's burgeoning population was now offered the choice of a residence in the suburbs, while still maintaining the convenience of easy access to the employment, shopping, and entertainment centered in downtown Los Angeles. As a result, once fashionable downtown neighborhoods, such as those that had developed in the 1880s surrounding Central Park and on Bunker Hill, began transforming into a realm of hotels and other businesses. The popularity of the automobile only accelerated this trend, making it even more convenient to live in suburban areas.

Despite this change, however, downtown Los Angeles continued to boom as a business and shopping center, offering fine hotels, a huge variety of restaurants, the highest concentration of theaters in the country, and some of the largest department stores in the West. Having long ago shed its pueblo beginnings, the city's metropolitan status was reaffirmed in 1920 when the population of Los Angeles exceeded that of San Francisco and again in 1930, when it became the fifth largest city in the nation.

When the postcard was introduced through an act of Congress in 1901, a postcard craze began, with tourists and residents alike mailing postcards by the millions across the country. Printed from photographs of almost any sight imaginable, early postcards provided a first glimpse into places most people had never seen before. Often advertising the businesses, stores, and hotels pictured as the finest, costliest, largest, or simply the best, postcards served their own important role in fueling the growth of the city. Together with the activities and promotional literature sent out by Los Angeles organizations such as the chamber of commerce, the sights presented on postcards encouraged thousands of new residents and tourists to come see the city for themselves. As much of the major growth of Los Angeles coincided with the years of the postcard craze, vintage postcards provide an important insight into downtown Los Angeles's development and expansion.

From the city's roots around the Plaza to its development as first a residential district and later as an important business, civic, shopping, and entertainment center, this collection of vintage postcards seeks to provide a glimpse into the city's transformation into a major metropolis, covering the years from the dawn of the 20th century up through the 1940s.

One

EARLY COMMUNITY LIFE

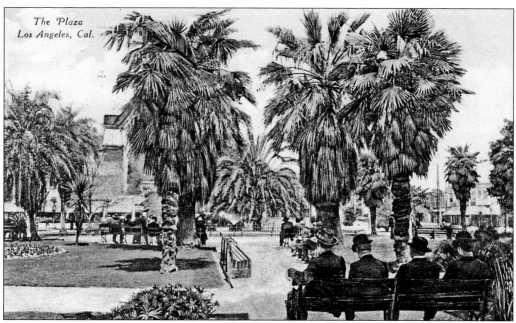

When Los Angeles was founded in 1781, the tiny Spanish pueblo was granted 6 miles of land in each direction radiating from a central plaza. Each settler family was provided with fields for planting and a lot for an adobe home. Throughout much of the 1800s, the Plaza continued to be a focal point in town life. Overlooked by the homes of the city's wealthiest families, the Plaza was the site of most important civic, business, social, and religious activities.

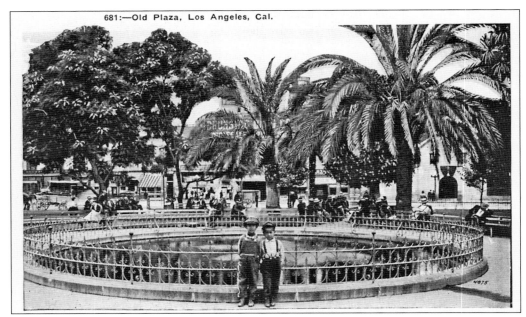

Shown here is another view of the Plaza. The fountain marks the location where a brick reservoir was constructed in the mid-1800s to store the city's water. In the days before the reservoir, water was collected from the city's irrigation ditches, known as *zanjas*, and delivered door to door. Visible on the right behind the palm trees is the Plaza Church.

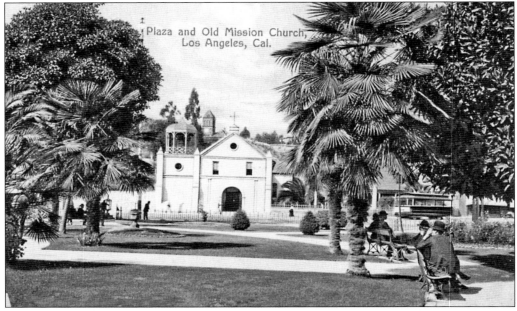

The Plaza Church, which has overlooked the Plaza since its completion in 1822, served Los Angeles residents who had previously had to travel to Mission San Gabriel for religious services. Though commonly known as the Plaza Church, the official name upon dedication was the Church of Our Lady of the Angels, later changed to Our Lady, Queen of the Angels. Visible just behind the church is the tower of Los Angeles High School.

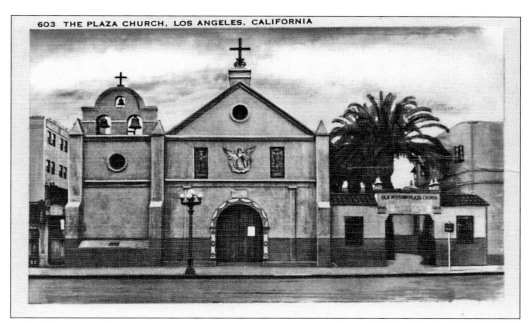

In this later view of the Plaza Church, the Victorian-style cupola has been replaced by a Mission-style bell tower. As the city expanded and the congregation grew, numerous alterations to the church occurred, including several major renovations and additions.

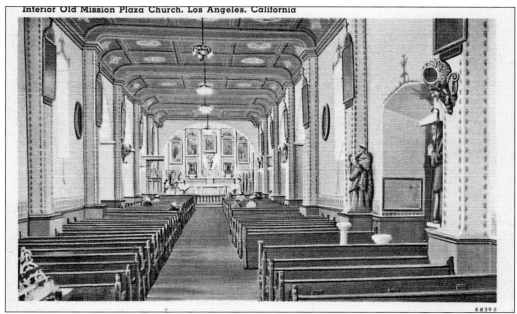

Shown here is the interior of the Plaza Church. Until the 1870s, the church was the only place of Catholic worship in the city. Now one of the oldest structures in Los Angeles, the Plaza Church continues to hold regular services.

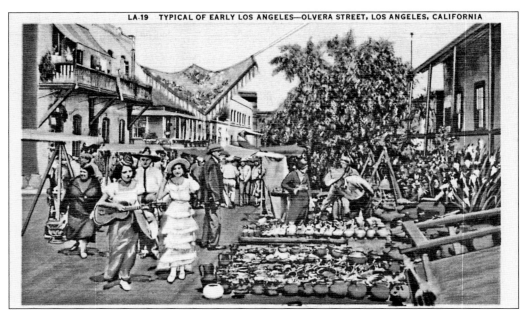

Once known as Wine Street because of its proximity to the city's vineyards, Olvera Street was renamed in honor of Los Angeles's first county judge, Agustin Olvera. In the late 1920s, when Christine Sterling learned that this small alley was threatened with demolition, she launched a successful campaign to save it. Together with the adjoining Plaza, Olvera Street was refurbished in the late 1920s, opening to the public in 1930 as an example of life in early Los Angeles.

602C:—Casa de Adobe, El Paseo de Los Angeles (Olvera Street), Los Angeles, Calif.

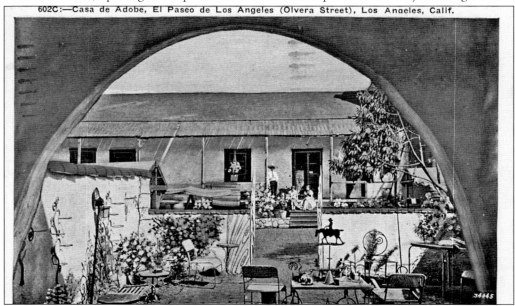

The Avila Adobe, restored as part of Olvera Street in 1930, is now the oldest surviving residence in Los Angeles. Built around 1818 by Francisco Avila, who served a term as the pueblo's mayor, the home was briefly occupied by Commodore Robert Stockton in 1847 during the Mexican-American War. Only one wing of what was an L-shaped house remains; the other portion was destroyed in an earthquake in 1857.

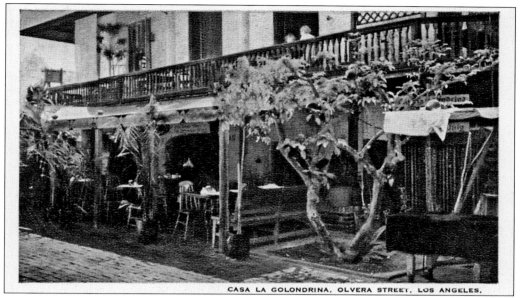

CASA LA GOLONDRINA, OLVERA STREET, LOS ANGELES.

The Pelanconi House, located on Olvera Street, was in the 1850s one of the first brick buildings to be constructed in the city. The building was purchased in 1865 by the Pelanconi family, who sold wine on the first floor and used the second floor as their personal residence. Renovated and reopened with Olvera Street in 1930, the wine cellar now houses La Golondrina Cafe.

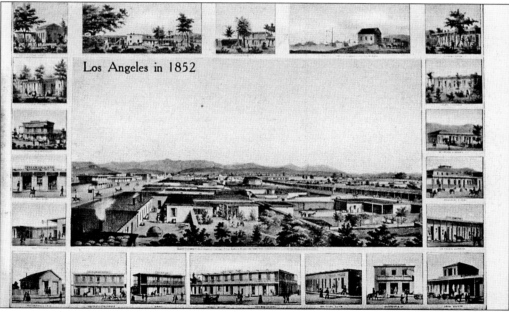

Los Angeles in 1852

This early–1900s postcard is a reprint of a lithograph produced by San Francisco firm Kuchel and Dressel in 1857. At center is the pueblo as it appeared in 1857, with the border composed of close-ups of several of the city's important shops and homes. Second from left at the bottom is the Bella Union Hotel, one of the earliest hotels. Second from bottom on the left margin is the city home of Abel Stearns, one of the area's largest landowners. At top, second from right, is San Pedro Harbor, the entry point to the city in the days before the railroad.

13

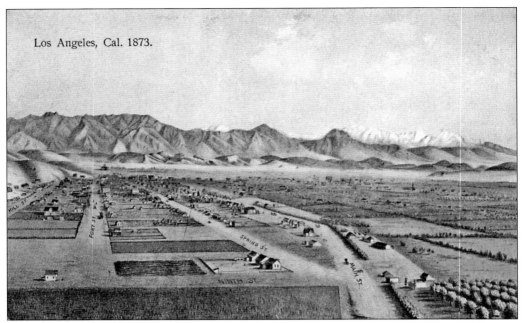

Los Angeles, Cal. 1873.

This postcard depicts Los Angeles in 1873, looking north toward the central residential and business district in the distance. At the time, the sparsely populated portion in the foreground was considered an outlying part of town. The area east of Main Street was primarily agricultural, home of orchards and vineyards.

4. PALMETTO AVENUE, LOS ANGELES, CALIFORNIA.

Postmarked in 1907, this postcard shows a view of Palmetto Avenue, which ran east from Alameda Street to the Los Angeles River. Until the city's growth was spurred by the arrival of the railroads in 1876, this area was dominated by vineyards and orchards. Rural scenes such as the one here soon disappeared, as agricultural pursuits were removed farther from the city center and the area became the site of factories and other industry.

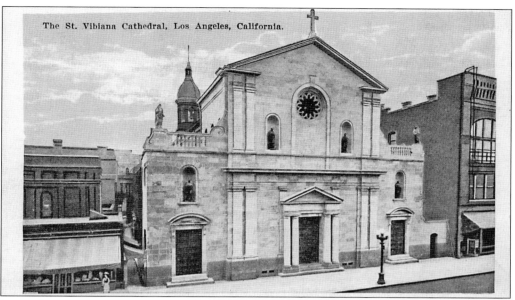

The St. Vibiana Cathedral, Los Angeles, California.

Located on Main Street near Second Street, St. Vibiana's Cathedral was dedicated in 1876. The image here shows the cathedral as it appeared in the 1920s, following the remodel of its facade. Now converted for other uses, St. Vibiana's served as the seat of the Catholic Archdiocese of Los Angeles until it was damaged by the 1994 Northridge earthquake. An impressive landmark when constructed, the cathedral housed relics of St. Vibiana, the child martyr for whom the cathedral was named.

Once considered "out in the country," the part of town seen in this real-photo postcard had transformed by the early 1900s into a quiet tree-lined neighborhood. Located just a few blocks from Main Street, this image was taken at the intersection of Ninth and Wall Streets. The church visible on Ninth Street is the Church of the New Christianity.

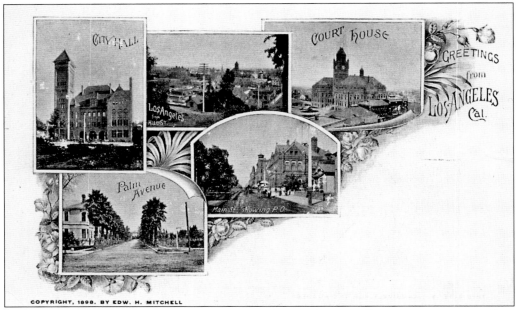

Showcasing scenes from 1890s Los Angeles, this postcard is actually an 1898 private mailing card, printed three years before the use of the word "postcard" was authorized by the U.S. government. Shown here are a view of residential Palm Avenue, an overview taken from Hill Street, a depiction of Main Street, and images of the city's two new civic buildings: the Los Angeles County Courthouse and the Los Angeles City Hall.

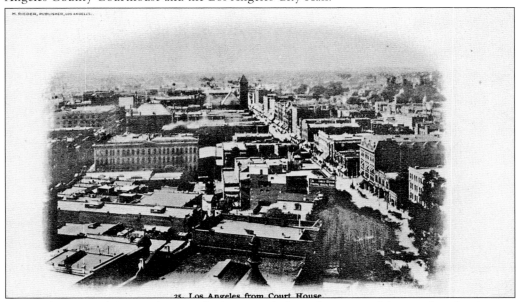

This early postcard depicts the view looking south from the tower of the Los Angeles County Courthouse, constructed in 1891 at Broadway and Temple Street. The business districts of Spring Street (running along the left) and of Broadway (at right) consist of three- and four-story businesses. The large, long structure at center left is the Hotel Nadeau, the first four-story building in the city and one of the finest hotels in the 1880s.

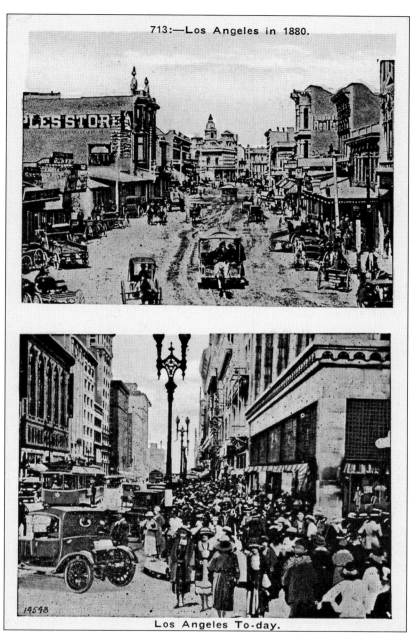

713:—Los Angeles in 1880.

Los Angeles To-day.

This postcard demonstrates how the main shopping districts changed between the 1880s and the 1920s. The top image faces north on Spring Street from First Street, showing what in 1880 was the heart of the business and retail district. Visible at left is Hamburger's People's Store in one of its early locations. The bottom image looks south on Broadway from Sixth Street, showing an area that in 1880 was considered out of town. Automobiles and streetcars on modern roads have replaced the horse and buggy rambling along the dirt roads seen at top. An indication of how far the business district expanded south in just a few decades, Hamburger's, the small store seen above, opened a giant department store at Broadway and Eighth Street in 1908, two blocks south of the intersection shown in the lower image.

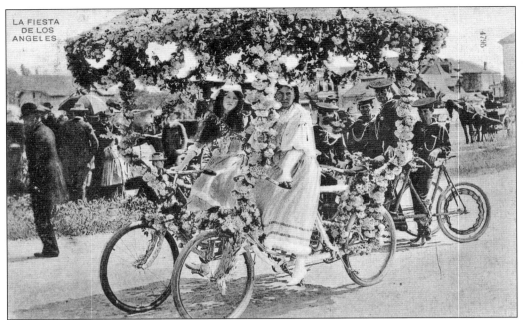

Shown here are some of the participants in La Fiesta de las Flores parade. First celebrated in 1894 as a means of attracting visitors to the city, La Fiesta activities were held over several days and included a parade, a grand ball, and a floral battle. Costumed Los Angeles residents participated in the parade by decorating any moving contraption they had, including the popular bicycle.

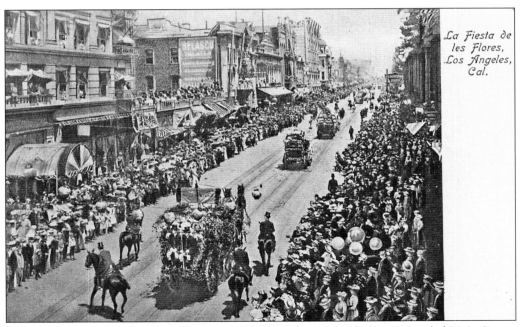

This 1909 postcard depicts a portion of La Fiesta parade as it travels down crowded Main Street. Presided over by a La Fiesta queen, the parade featured floats decorated with flowers, horse riders, and bands. The event proved so popular that it was repeated in many subsequent years.

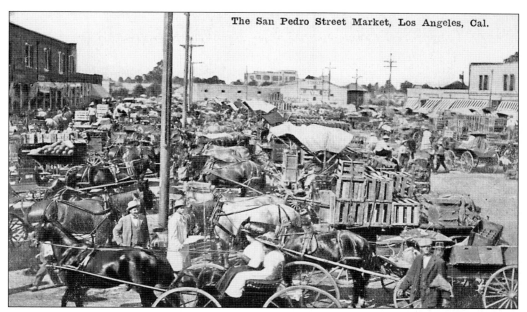

The San Pedro Street Market, Los Angeles, Cal.

In early Los Angeles, the Plaza served as the site for a produce marketplace where vendors could display their wares on market day. Later, as the area around Los Angeles Street and east on to the Los Angeles River developed as a wholesale and industrial district, other markets appeared, such as the San Pedro Street market shown here. In the background is the H. Jevne Company, which would grow to become the largest and best-stocked grocery in the city, with a prosperous store on Broadway and Sixth Street.

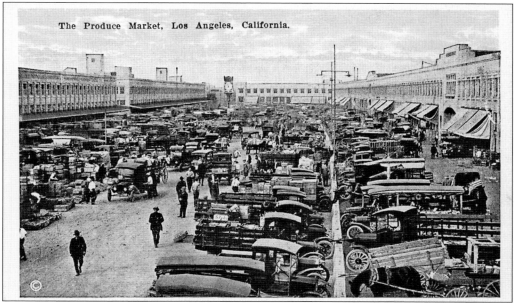

The Produce Market, Los Angeles, California.

The Terminal Market, located at Seventh and Central Streets, was constructed in 1918 to provide a larger central marketplace for wholesale produce. Where the previous scene was crowded with horses and buggies, this new market was designed to be large enough to accommodate automobile traffic.

19

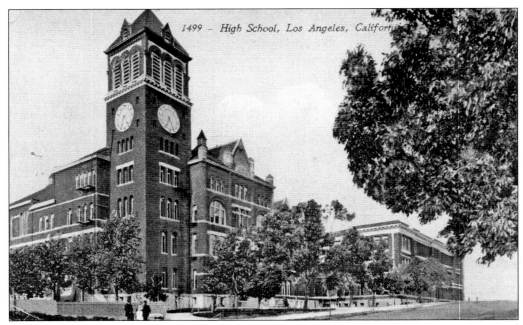

Founded in 1873, Los Angeles High School was the city's first high school. In 1891, the school moved from Broadway and Temple Street to its new building, shown here, at North Hill Street. In 1917, the school relocated again, to its current location on Olympic Boulevard.

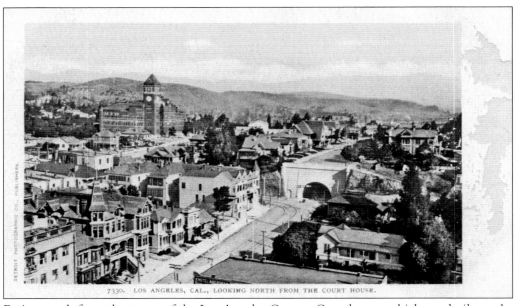

Facing north from the tower of the Los Angeles County Courthouse, which was built on the site of the first Los Angeles High School at Broadway and Temple Street, this view shows the second building of the Los Angeles High School, nestled among the residential streets of Hill Street and Broadway. Across from the high school, located on top of the North Broadway tunnel visible near the right, once stood Fort Moore, dedicated in 1847. The street now known as Broadway was originally called Fort Street in honor of Fort Moore.

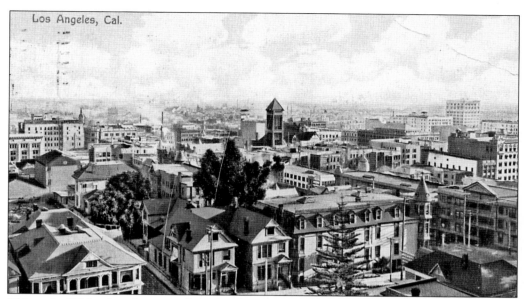

This early-1900s view faces east from Bunker Hill, overlooking the city from First Street and Grand Avenue. While the foreground, showing Olive and Hill Streets between First and Second Streets, is still predominately a residential neighborhood, the business district is quickly edging west. In the center of the image is the tower of city hall, located on Broadway between Second and Third Streets. At far right is the 1904 Braly Building, the city's tallest structure at the time.

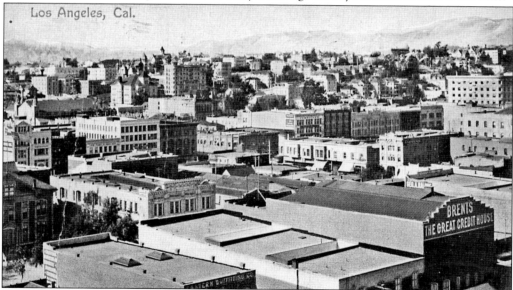

This image from the start of the 20th century looks northwest from Main and Sixth Streets, showing the growing business district in the foreground. In the background is Bunker Hill, subdivided by Prudent Beaudry into a fashionable district of Victorian mansions beginning in 1869. Just above the halfway point on the far left side is the double-spired Hazard's Pavilion, located at Fifth and Olive Streets. The city's largest entertainment venue in the late 1800s, the pavilion showcased celebrity appearances, meetings, festivals, plays, and operas. It was demolished in 1905 and replaced with the Auditorium, which hosted similar entertainment events.

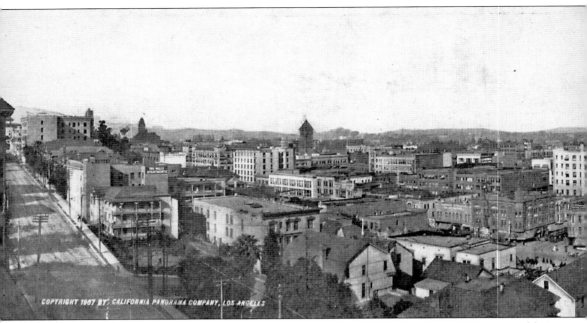

This 1907 panorama faces east over the city from Bunker Hill. Several residences are visible in the foreground, while the background shows the skyline of the growing business district. The tallest building, near the center, is the Braly Building, constructed as the city's first skyscraper in 1904. In this image, the building is occupied by the German American Savings Bank, who had

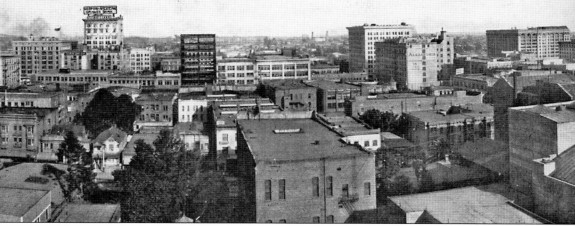

New Location of the
**GERMAN | AMERICAN
SAVINGS ↓ BANK**

this postcard printed to showcase their location. The three tallest structures at far right on the skyline are the Hotel Alexandria, the Security Building, and the Pacific Electric Building. All located on Spring Street, these three recently completed structures were the latest developments in the rapid southward expansion of the business district.

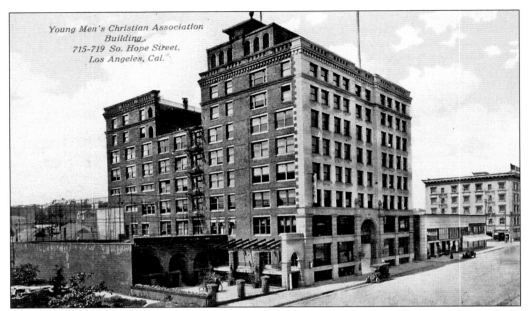

The Los Angeles branch of the Young Men's Christian Association, known as the YMCA, was founded in 1882 by Samuel Merrill, a California businessman and philanthropist. Based on Christian values, the organization sought to promote healthy minds and bodies among the city's young men. As the organization grew, it was able to construct a new building to house its facilities, seen here at Hope and Seventh Streets.

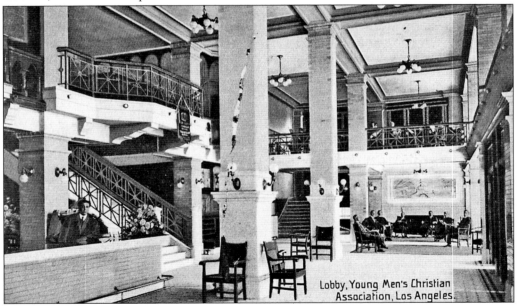

This postcard depicts the lobby of the YMCA's building at Hope and Seventh Streets. In addition to providing a gym, pool, and athletic training, the YMCA also offered job training and clean, inexpensive rooms available to single young men. In its mission to support strong communities, the organization began offering a variety of family programs, including its popular camping trips, in the 1920s.

The Los Angeles Athletic Club was founded in 1880 by a group of 40 young men. Operating out of rented rooms for many years, club members enjoyed social camaraderie while engaging in fitness training and athletic events. In 1907, the club purchased the property at Olive and Seventh Streets, and plans were begun to construct a new club containing the most modern athletic facilities. The completed building, seen here, was opened with a three-day celebration in 1912.

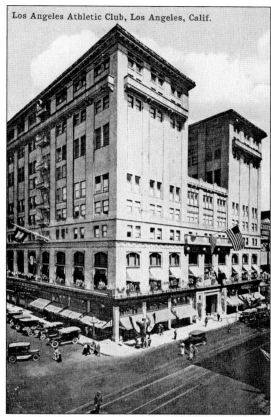

Los Angeles Athletic Club, Los Angeles, Calif.

Shown here is the Los Angeles Athletic Club's swimming pool, located on the sixth floor of their new building at Olive and Seventh Streets. This pool was considered an engineering feat at a time when most pools were relegated to the basement, a result of the weight of the water. The club featured top-of-the-line athletic facilities and hired some of the best trainers, producing several Olympic medal winners. The building also contained dining and social rooms, as well as guest rooms on the top floors where bachelor members could take up residence.

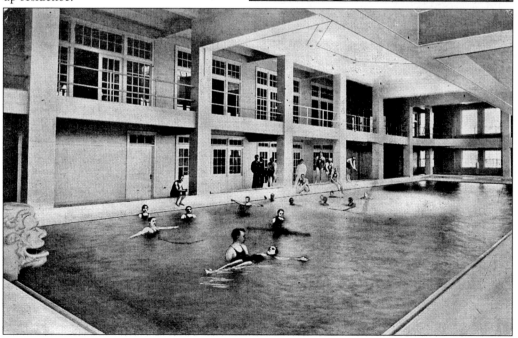

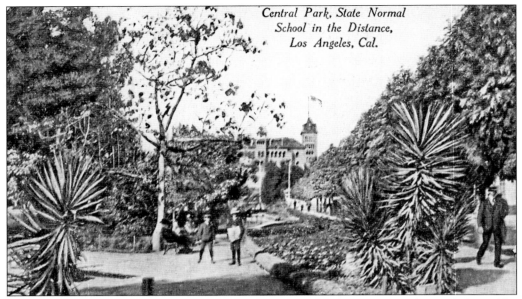

Central Park, State Normal School in the Distance, Los Angeles, Cal.

The only park in downtown Los Angeles other than the Plaza, Central Park was dedicated by Mayor Cristobal Aguilar in 1866. Bounded by Fifth, Sixth, Olive, and Hill Streets, the park has had many names over the years, including Lower Plaza, St. Vincent Park, Los Angeles Park, Sixth Street Park, and Central Park. In 1918, the name was changed to Pershing Square in honor of Gen. John Pershing, a World War I commander. In this early postcard, the State Normal School overlooks the park from its location at Fifth Street and Grand Avenue.

Sixth Street Park, Los Angeles, Cal.

When Central Park was dedicated, it had few visitors thanks to a location distant from the city center of the time. The first attempts to beautify the park were carried out by citizens who planted a variety of donated plants. The park's first official layout was effected in 1886, based on a design by city engineer Fred Eaton. This postcard shows this design, which featured winding pathways and a central bandstand where weekend concerts were held.

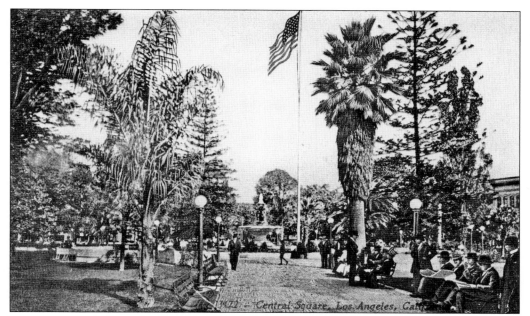

In 1911, a new, more formal layout for Central Park was implemented, using the design of architect John Parkinson. The winding pathways were replaced by diagonal walkways, allowing a more direct route across the park. This 1912 postcard shows one of these walkways and the fountain placed at center, where the bandstand once stood.

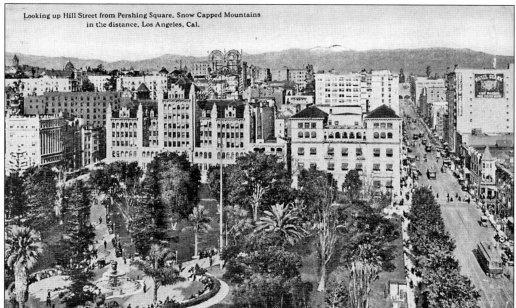

Looking north over Central Park, this postcard shows an overview of the 1911 Parkinson design. By the time of this image, the business district had begun expanding into the area, replacing many of the homes, churches, and schools that had once surrounded the park. The largest structure overlooking the park in this image is the Auditorium, built in 1906. To its right is the California Club, built in 1904.

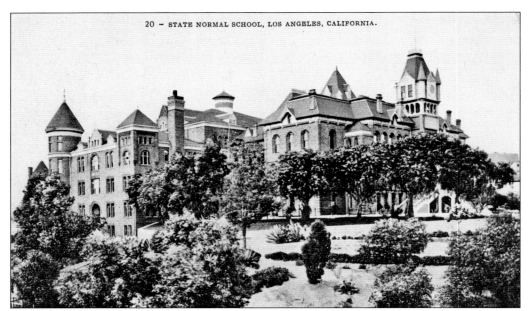

In response to the growing city's need for institutions of higher education, the State Normal School opened in 1882 to provide teacher training. The second such school in California, the State Normal School overlooked Central Park from Fifth Street and Grand Avenue until 1914, when it relocated to a larger campus on Vermont Avenue in Hollywood. The school later became the southern branch of the University of California, the predecessor of UCLA.

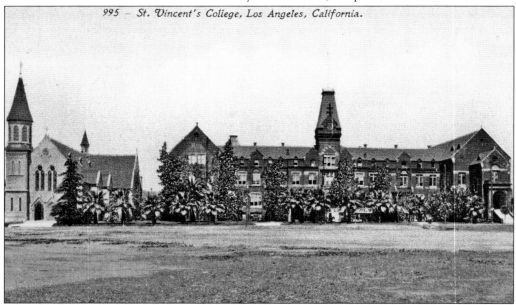

995 – St. Vincent's College, Los Angeles, California.

Shown here is St. Vincent's College at its third location at Washington Boulevard and Grand Avenue. Founded in a donated adobe on the Plaza, St. Vincent's moved in 1867 to a two-square-block campus adjacent to Central Park. This campus, bounded by Sixth, Seventh, and Olive Streets and Broadway, was used until 1887, when the larger campus above was acquired. St. Vincent's College was a forerunner of Loyola Marymount University.

Postmarked in 1910, this real-photo postcard pictures the spire of St. Paul's Cathedral. Located adjoining Central Park on Olive Street between Fifth and Sixth Streets, the church was constructed in 1883. St. Paul's traces its beginnings to 1865, when the city's first Protestant church formed under the name of St. Anthanasius Episcopal. The name was changed to St. Paul's in the 1880s.

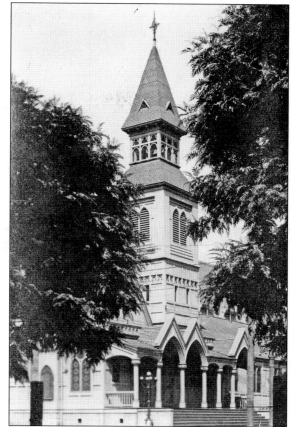

St. Paul's Cathedral was an important part of the Central Park neighborhood for many years, from 1883 to 1922. At this point, the property was sold to make way for the Biltmore Hotel, and St. Paul's began construction on a new cathedral at Figueroa and Sixth Streets.

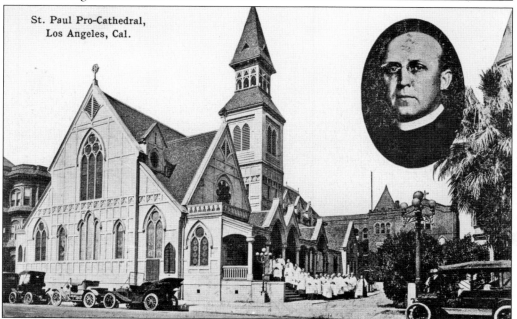

St. Paul Pro-Cathedral,
Los Angeles, Cal.

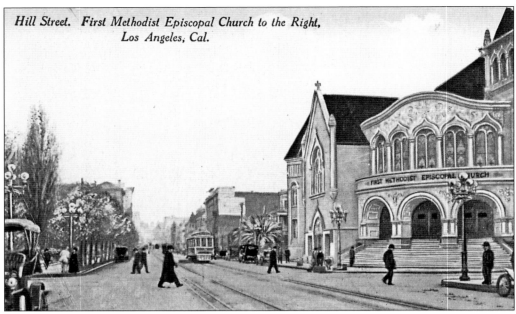

Hill Street. First Methodist Episcopal Church to the Right, Los Angeles, Cal.

Shown here is the view down Hill Street, looking north from Sixth Street. On the right is the First Methodist Episcopal Church, which overlooked Central Park for many years at the dawn of the 20th century. The park is visible on the left, across the street from the church.

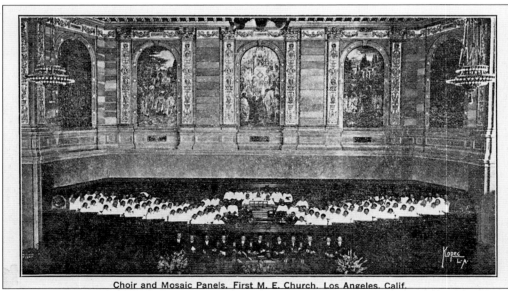

Choir and Mosaic Panels. First M. E. Church. Los Angeles, Calif.

This postcard pictures the choir of the First Methodist Episcopal Church. Methodist worship began in Los Angeles in the 1850s, with regular services beginning in 1868 at a small church on Broadway. The growing congregation began construction in 1899 on the 1,500-seat church, seen in the previous image, at Hill and Sixth Streets. In 1923, the congregation moved to even larger quarters at Eighth and Hope Streets. The church at the Central Park site was demolished and replaced with Sid Grauman's Metropolitan Theater.

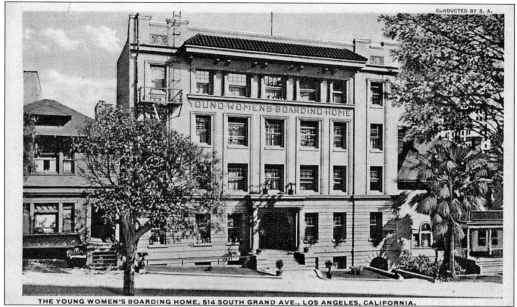

THE YOUNG WOMEN'S BOARDING HOME, 514 SOUTH GRAND AVE., LOS ANGELES, CALIFORNIA.

Opened in 1909 in what was at the time a quiet residential neighborhood on Grand Avenue, the Salvation Army's Young Women's Boarding Home offered daily meals and maid service for independent young women. The Salvation Army sold the property in 1923 to make way for the Biltmore Hotel, using the profit to construct a larger boarding home at Sixth and Boyleston Streets.

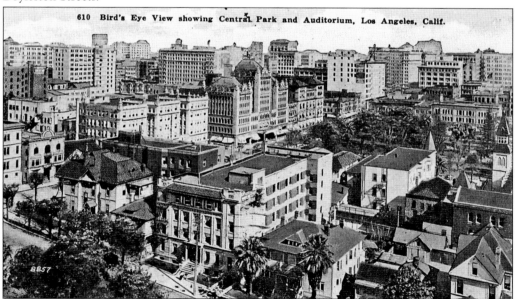

610 Bird's Eye View showing Central Park and Auditorium, Los Angeles, Calif.

This view, taken from the Bible Institute at Sixth and Hope Streets, looks east over Central Park, with the many height-limit buildings of the business district visible on the skyline. The Young Women's Boarding Home, the largest structure near the center of the foreground, is visible on Grand Avenue, the street running across the lower left corner. The majority of this block would be demolished in the early 1920s in order for construction to proceed on the Biltmore Hotel.

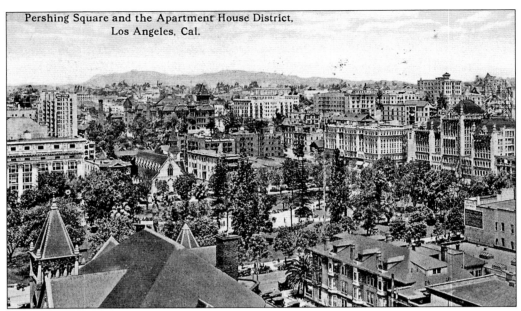

Pershing Square and the Apartment House District,
Los Angeles, Cal.

Postmarked in 1920, this postcard image faces west over the Central Park neighborhood, occupied by apartment houses, churches, and hotels. At bottom left is the roof of the First Methodist Episcopal Church, and across the park is St. Paul's Cathedral. The large building seen just above the spire of St. Paul's is the State Normal School.

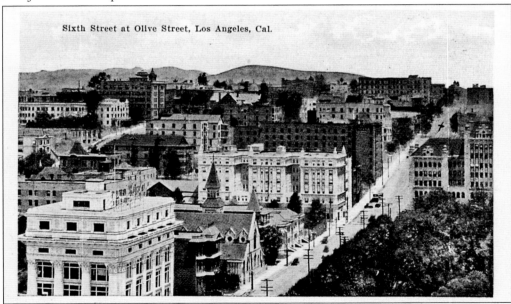

Sixth Street at Olive Street, Los Angeles, Cal.

This view looks north on Olive Street from Sixth Street, showing part of the Central Park and Bunker Hill neighborhoods. In the 1870s and 1880s, Bunker Hill had been the neighborhood of choice for the city's elite, but by the time of this image, sometime in the 1910s, many of the fine residences had given way to rooming houses and hotels. The long three-towered building at the center of the image is the Auditorium Hotel. Just up the hill to the north is the Hotel Trenton. At the bottom left is the Pacific Mutual Building, constructed in 1908.

32

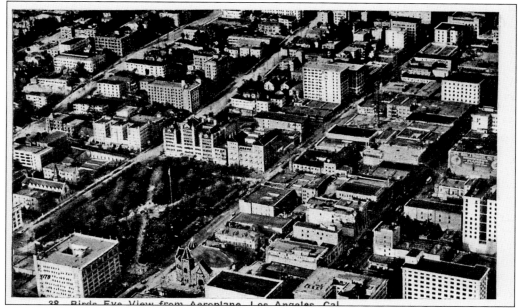

This 1915 postcard provides an aerial view of Central Park before it became part of the business district. Above the word "Aeroplane" appears the First Methodist Episcopal Church, and to the left of the park is St. Paul's Cathedral. At the center of the image, on the north side of the park, are the Auditorium and the California Club. To the left of the Auditorium is the recently constructed Auditorium Hotel, soon to be overshadowed by the Biltmore Hotel. The upper left corner shows some of the rooming houses, apartments, and hotels of the Bunker Hill neighborhood.

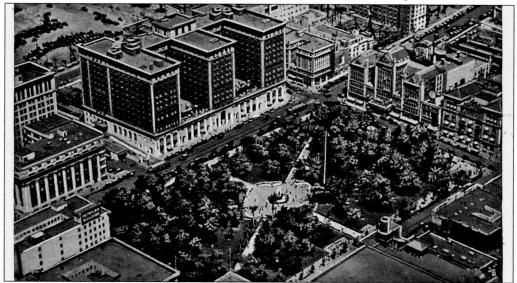

This postcard provides a view of Central Park, now renamed Pershing Square, showing the changes that had occurred by the mid-1920s. The First Methodist Episcopal Church and St. Paul's Cathedral have been demolished, and the luxurious Biltmore Hotel, opened in 1923, dominates the neighborhood. At the top left, behind the Biltmore Hotel, is a parking lot where the State Normal School once stood. This site would soon be occupied by the Los Angeles Public Library.

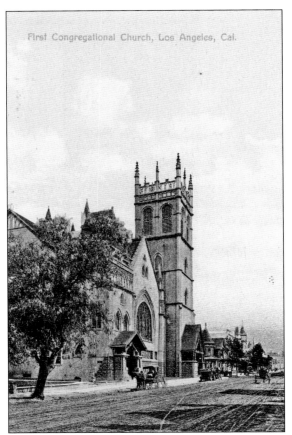

First Congregational Church, Los Angeles, Cal.

Shown here is the fourth location of the First Congregational Church, which was organized in 1867. The church was located at Sixth and Hill Streets, near Central Park, from 1870 to 1903. In 1903, the church moved to the structure shown here, situated at Ninth and Hope Streets. This church was used until 1932, when the congregation made a final move to their present church at Sixth and Commonwealth Streets.

Postmarked in 1906, this postcard shows the Christ Episcopal Church, located at Twelfth and Flower Streets. In 1916, this building was acquired by the Trinity Methodist Church, which had been founded in the 1860s. Trinity Methodist Church operated from this location from 1919 until 1973, when it merged with Wilshire United Methodist Church.

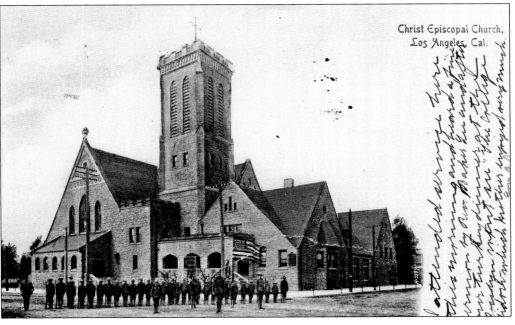

Christ Episcopal Church, Los Angeles, Cal.

This 1912 postcard shows Temple B'nai B'rith, a 600-seat synagogue at Ninth and Hope Streets. Formed in 1862, Congregation B'nai B'rith constructed their first building at Broadway and Temple Street in 1873. The new temple, shown here, was dedicated in 1896 and contained stained-glass windows presented by some of the city's leading Jewish families. In 1929, the congregation moved to the Wilshire Boulevard Temple, widely recognizable today for its impressive Byzantine-style dome.

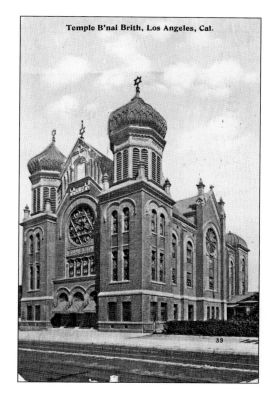

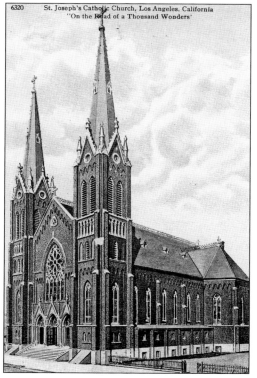

Shown here is St. Joseph's Church, a Catholic cathedral notable for it Gothic architecture. Located at Twelfth and Los Angeles Streets, the cathedral was dedicated in 1903. Containing seven altars and huge stained-glass windows, St. Joseph's served downtown Los Angeles until it was destroyed by a fire in 1983.

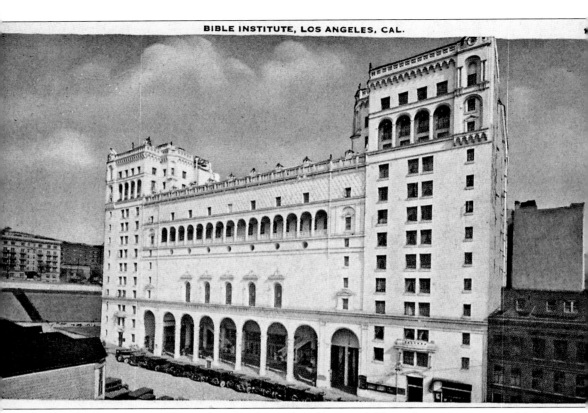

The Bible Institute of Los Angeles, located at Sixth and Hope Streets, was a combination evangelical training center and church. Built in 1914, the school's classrooms and dorms were located in the south wing, while the center section housed a 3,500-seat auditorium used for the services of the Church of the Open Door. The school's name, the Bible Institute of Los Angeles, was later shortened to Biola, using the first letter of each word. While the church continued to use the building until it was demolished in 1988, Biola University relocated to La Mirada in 1959.

Two

BUSINESS AND CIVIC DEVELOPMENT

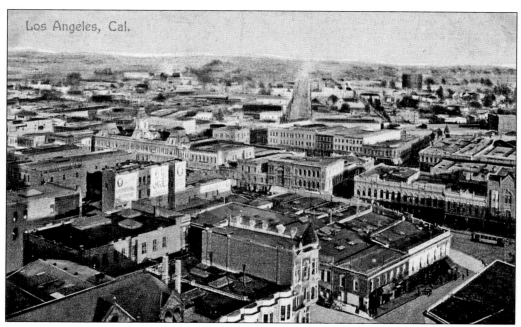

Composed of two- and three-story buildings, the heart of the business district of downtown Los Angeles is shown here as it appeared in the late 1800s. Main Street, the center of business for several decades starting in the mid-1800s, runs across the middle of the image. The largest structure, toward the left on Main Street, is the Baker Block, built in 1877 as the first modern office block. Toward the turn of the 20th century, the business center began shifting south and west, with new impressive structures appearing on Spring Street and Broadway.

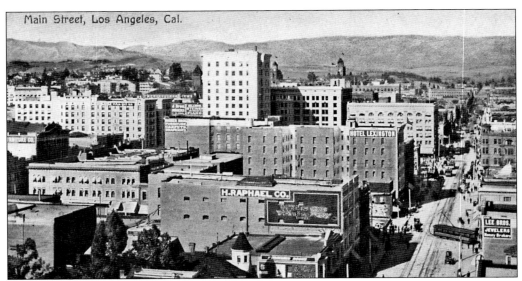

Main Street, Los Angeles, Cal.

Looking north from Sixth Street along Main Street, this early-1900s view shows a greatly expanded business district. The Angelus Hotel, one of the finest when it opened in 1901, is visible on the left at Spring and Fourth Streets. At right middle, along Main Street, is the Hotel Lexington, which opened in 1903 and later became the Hotel Rosslyn. The tall building at center, the Braly Building, was built in 1904 at Spring and Fourth Streets and remained the tallest structure on the skyline until the new city hall was built in 1928. In the distance are the three spires of early downtown's important civic buildings, from left to right: the city hall, the high school, and the county courthouse.

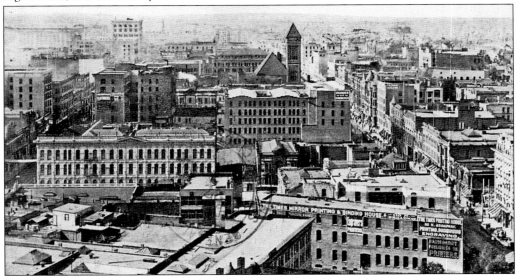

This early-1900s view faces south, showing Broadway along the right and Spring Street at left. The large, long structure at mid-left is the Nadeau Hotel, constructed in 1882 at First and Spring Streets and later demolished for the 1935 Los Angeles Times Building. At lower right on Broadway is the Times Mirror Printing and Binding House, printer of the successful *Los Angeles Times* newspaper. The chamber of commerce building is visible on Broadway just south of First Street, next to the spire of city hall.

This 1905 postcard shows Los Angeles City Hall, which served the city from 1888 to 1928. Located on Broadway between Second and Third Streets, the new building proved to the booming populace how sophisticated the city had become since the pueblo days, when city functions were carried out in an adobe structure near the Plaza.

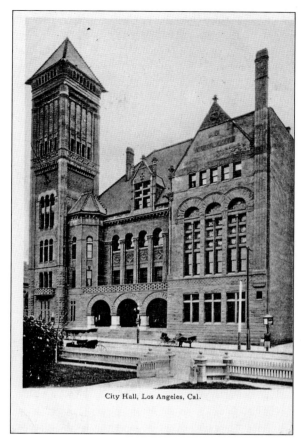

City Hall, Los Angeles, Cal.

Constructed in 1891, the Los Angeles County Courthouse is shown here from the corner of New High and Temple Streets. The landmark red sandstone courthouse stood where the city's first high school had been located from 1873 until it moved to North Hill Street to allow for construction of the courthouse.

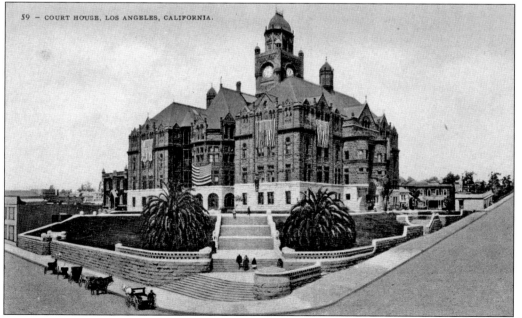

59 – COURT HOUSE, LOS ANGELES, CALIFORNIA.

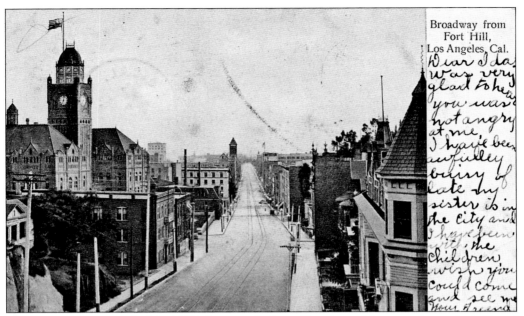

This postcard, postmarked in 1907, faces south down Broadway. The courthouse (at left) and the city hall in the distance dominate the Broadway skyline of three- and four-story businesses. Just right of the courthouse in the distant background is visible the city's tallest building at the time, the Braly Building.

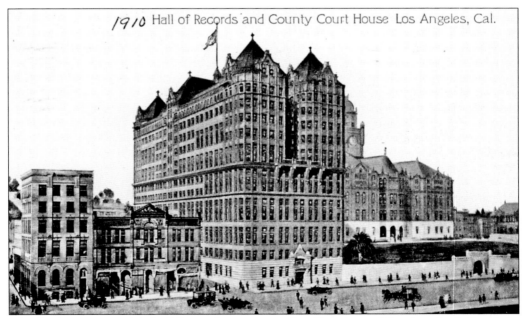

The third important civic building to be constructed on Broadway, following city hall and the courthouse, was the Hall of Records. Completed in 1912, the Hall of Records extended from Broadway to New High Street, adjacent to the courthouse.

This view was taken looking north up Broadway, with city hall dominating on the right. In the distance is visible the clock tower of the county courthouse at Broadway and Temple Street.

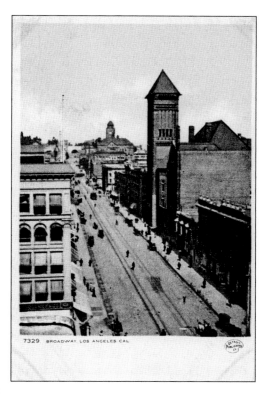

7329 BROADWAY, LOS ANGELES CAL.

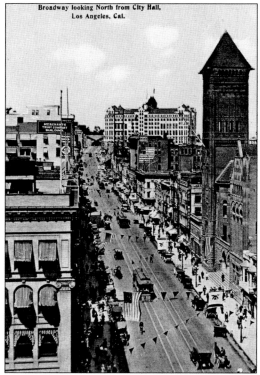

Broadway looking North from City Hall,
Los Angeles, Cal.

This view, taken from the same perspective as the previous image, shows how the skyline has changed in just a few years. A few buildings beyond city hall is the new chamber of commerce building. Finished in 1912, the large Hall of Records, seen in the distance on the right, now obscures the view of the courthouse.

41

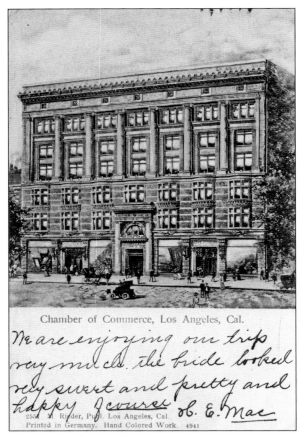

Chamber of Commerce, Los Angeles, Cal.

We are enjoying our trip very much the bride looked very sweet and pretty and happy of course

C. E. Mac

255 M. Rieder, Publ. Los Angeles, Cal
Printed in Germany. Hand Colored Work. 4941

The Los Angeles Chamber of Commerce was founded with the purpose of promoting the city and attracting both tourists and new residents. Though the original formation in 1873 lasted only a few years, the chamber of commerce that was reestablished in 1888 was widely successful in its mission. Members promoted the Southern California region by distributing literature and attending conventions across the country. Their offices, shown in this 1905 postcard, were located on Broadway near First Street.

Not only did the Los Angeles Chamber of Commerce develop promotional literature, it operated an exhibit hall on the second and third floors of its building at Broadway and First Street. Thousands of visitors annually stopped to view the exhibits of the region's attributes and history, including displays of mission relics and arrangements of fruit and agricultural products.

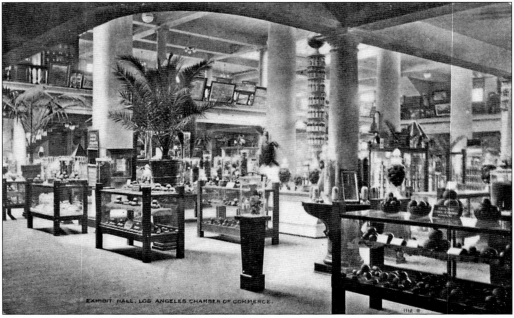

EXHIBIT HALL, LOS ANGELES CHAMBER OF COMMERCE.

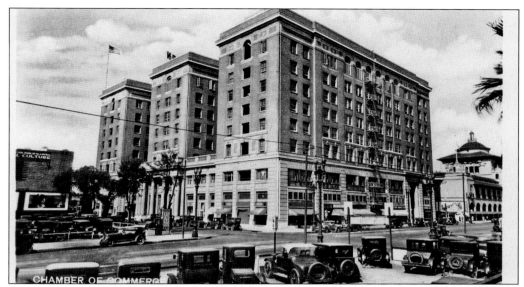

As the population of Los Angeles exploded and the downtown business district expanded south, the chamber of commerce felt the need for larger quarters more appropriate to the new metropolitan status of the city. This real-photo postcard shows their new headquarters at Broadway and Twelfth Street, completed in 1925.

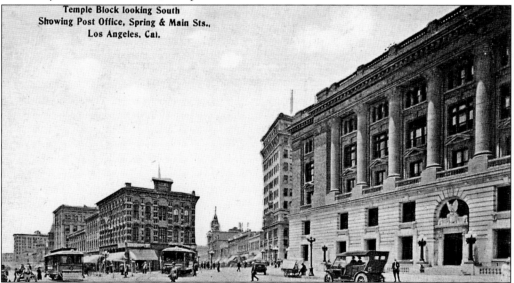

This postcard shows the convergence of Spring, Main, and Temple Streets, with the Los Angeles Post Office at right. The building at left is the Temple Block, located on the corner where Temple Street meets Main Street, which comes in from the left, and Spring Street, which angles in from the right. Constructed by prominent early businessman John Temple in 1858, the Temple Block was a fixture of the business district in the late 1800s, used as a market, meeting hall, and courthouse. A later addition to the block, completed by Temple's brother Francisco, housed the Temple Workman Bank, founded in 1871. On Spring Street, to the right of the Temple Block, is visible the spire of the 1887 Phillips Block, another important early business block. All the structures in this image would be razed to construct the new civic center in the late 1920s.

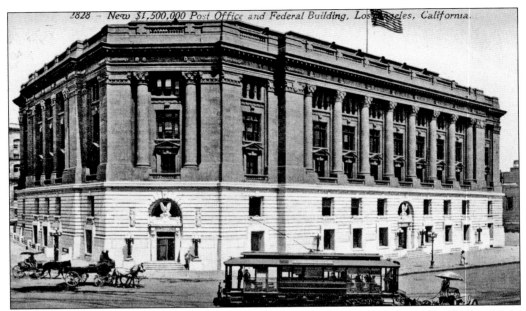

This 1911 postcard depicts the post office and federal building constructed in 1908 at Main Street, which runs in the foreground, and Temple Street, on the left. Costing over $1 million, the building was the second built in the city for federal purposes. The first, used from 1893 to 1908, was located at Main and Winston Streets. The site at Main and Temple Streets had previously been occupied by the Downey Block, a business block constructed by former California governor John Downey. From 1872 to 1889, the Downey Block served as the first home of the Los Angeles Public Library.

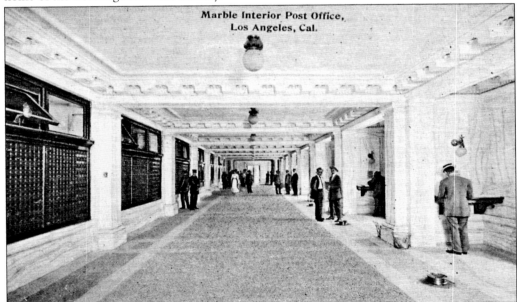

Shown here is the impressive marble interior of the post office at Main and Temple Streets. This post office was in use from 1908 until it was razed to clear the way for the larger post office and federal building, completed on the same location in 1939 as part of the new civic center.

Looking north on Spring Street from First Street, this 1910 view shows the approach to the post office, visible at the intersection with Temple Street just past the International Savings and Exchange Bank. On the left is the Phillips Block, built in 1887 as the second four-story building in the city. In the 1890s, Hamburger's People's Store, a popular department store, was located in this building. In the mid-1920s, both sides of this portion of Spring Street were flattened for the new Los Angeles City Hall. Spring Street, shown here veering right to meet Main and Temple Streets, was realigned to travel toward the left, making the street parallel to Main Street.

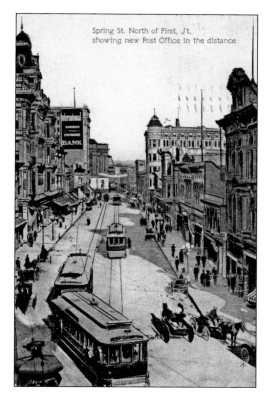

Spring St. North of First, St. showing new Post Office in the distance

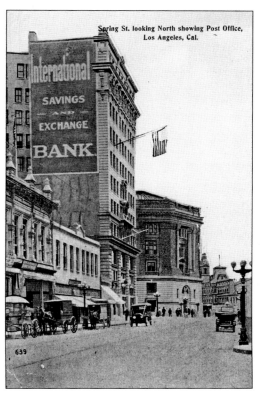

Spring St. looking North showing Post Office, Los Angeles, Cal.

This postcard provides a closer view of the intersection in the previous image, where Spring Street dead-ends into Temple Street. The structure on Main Street at far right, past the post office, is the Baker Block, built in 1877 as the most impressive business block of its day. Baker, who married Arcadia Stearns, the widow of pioneer businessman Abel Stearns, constructed the building on the site of the Stearnses' old adobe home. This home, a centerpiece of mid-1800s social life, was so grand at its height that it was called El Palacio.

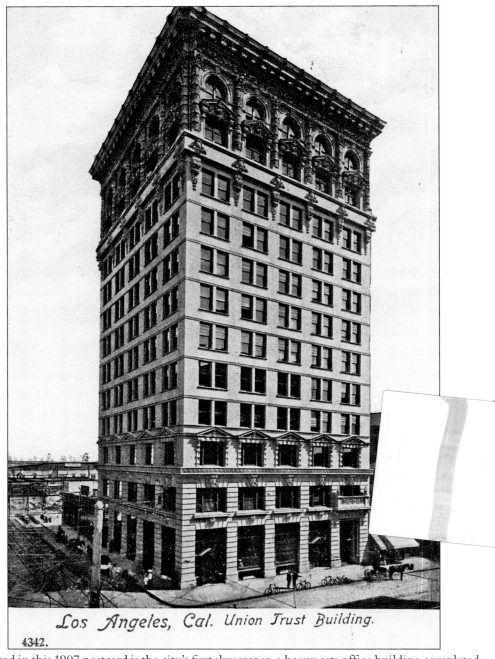

Los Angeles, Cal. Union Trust Building.

4342.

Pictured in this 1907 postcard is the city's first skyscraper, a beaux arts office building completed in 1904 at Spring and Fourth Streets. Designed by John Parkinson, the building was originally known as the Braly Building, although it would later be referred to as the Union Trust Building, the Hibernian Building, and then as the Continental Building. After a height limit of 150 feet was imposed by the city council in 1906, just after the building's completion, the 175-foot Braly Building would stand as the tallest landmark on the city's skyline until 1928, when a height exemption was granted for the construction of the new Los Angeles City Hall.

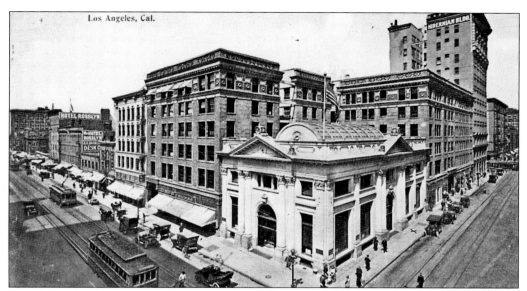

Shown here at the corner of Main and Fourth Streets is the Farmer's and Merchant's Bank, built in 1904. In 1868, Isaias Hellman founded the city's second bank together with William Workman and Francisco Temple. Temple's older brother, John Temple, was a prominent early businessman, responsible for both the city's first store in the 1820s and for the Temple Block, the city's first business block, at Main and Temple Streets. In 1871, the bank partnership was bought out by Hellman, who then joined with former California governor John Downey to form Farmer's and Merchant's Bank. Temple and Workman went on to establish Temple and Workman Bank.

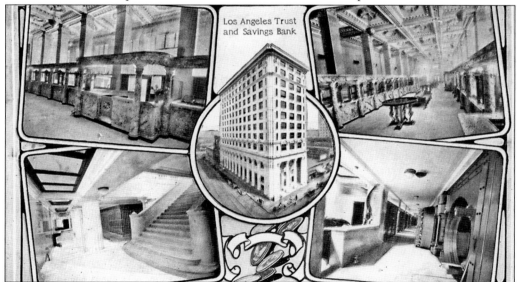

By 1910, when the Los Angeles Trust and Savings Bank building was completed at Spring and Sixth Streets, Spring Street had become the city's financial and banking center. The building shown here was designed by John Parkinson and G. Edwin Bergstrom, prolific architects who were responsible for numerous Spring Street financial buildings, including the Security Building and the Los Angeles Stock Exchange. In 1922, Los Angeles Trust and Savings Bank changed its name to Pacific Southwest Trust and Savings Bank.

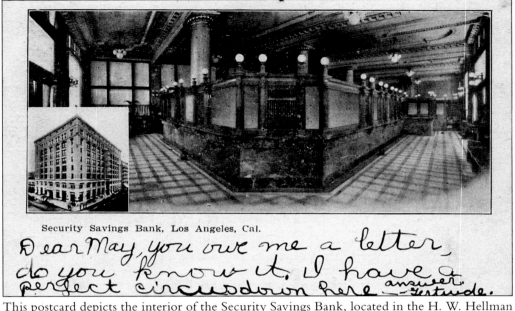

Security Savings Bank, Los Angeles, Cal.

Dear May, you owe me a letter, do you know it. I have a perfect circus down here answer. —Gertrude.

This postcard depicts the interior of the Security Savings Bank, located in the H. W. Hellman Building at Spring and Fourth Streets. Founded as a loan company in 1888, it began operating as a savings and deposit bank in 1889 under the name Security Trust and Savings Bank. The name was changed to Security Savings Bank in 1896, although the bank reverted to its original name in 1912.

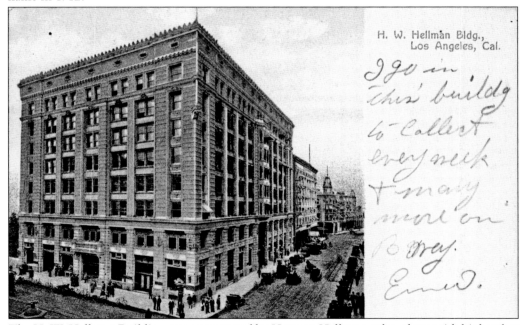

H. W. Hellman Bldg.,
Los Angeles, Cal.

I go in this buildg to collect every week + many more on Co way. Ernest.

The H. W. Hellman Building was constructed by Herman Hellman, who, along with his brother Isaias, played a formative role in early Los Angeles banking. As the financial center of the city shifted from Main Street to Spring Street at the beginning of the 20th century, the Security Savings Bank relocated to this building in 1904 from its offices at Main and Second Streets.

Having become the largest bank in the city, the Security Savings Bank moved in 1907 from the H. W. Hellman Building to the building shown here at Spring and Fifth Streets. Known as the Security Building, the structure was completed in 1906 by architects John Parkinson and G. Edwin Bergstrom, who had recently designed the Alexandria Hotel, located just across the street.

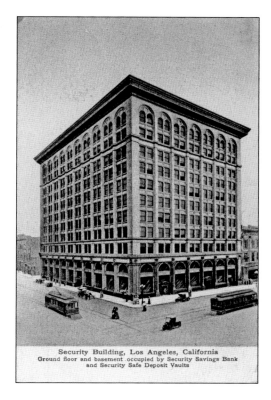

Security Building, Los Angeles, California
Ground floor and basement occupied by Security Savings Bank and Security Safe Deposit Vaults

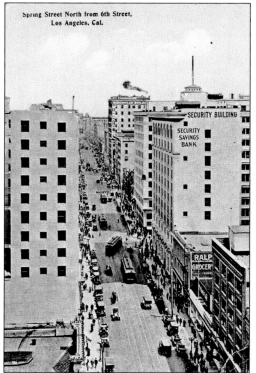

Spring Street North from 6th Street, Los Angeles, Cal.

This postcard provides a view of the city's financial district, looking north on Spring Street from Sixth Street. The Security Building is visible on the right, as is the Hibernian Building, located in the distance at Fourth Street. Ralphs Grocery Company, next to the Security Building, was founded as a small store by George Ralphs in 1873, growing over the years into the popular grocery chain now familiar to most Southern Californians. At left is the 12-story Alexandria Hotel annex, added a few years after the fashionable hotel's opening in 1906.

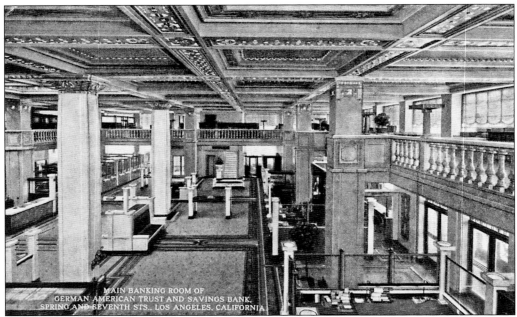

Shown here is the main banking room of the German American Trust and Savings Bank, headquartered at Spring and Seventh Streets. Founded in 1890, the bank changed its name to Guaranty Trust and Savings Bank in 1917 in response to the anti–German sentiment surrounding World War I. In 1921, the bank merged into Security Trust and Savings Bank.

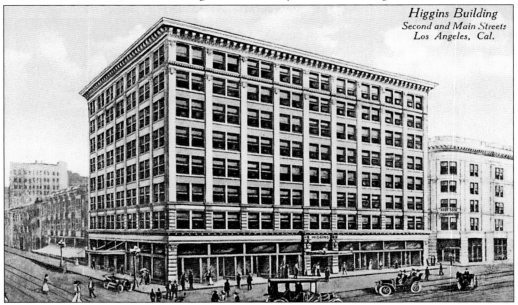

This postcard shows the Higgins Building, constructed in 1910 by copper entrepreneur Thomas Higgins at Main and Second Streets. Released as an advertisement for the new office building before its grand opening, the caption on the reverse proclaims, "It will be as thoroughly fire and earthquake proof as modern appliances and engineering skill can make it. Every known improvement for the comfort and convenience of tenants will be installed."

Postmarked in 1910, this postcard depicts the Walter P. Story Building shortly after its completion at Broadway and Sixth Street. Designed by Octavius Morgan and John Walls, the office building replaced an earlier structure of the same name dating to 1900. Along with other new impressive structures such as the Security Building, the Alexandria Hotel, the H. W. Hellman Building, the Pacific Electric Building, and Hamburger's Department Store, the building helped fuel the southward movement of the city's business center.

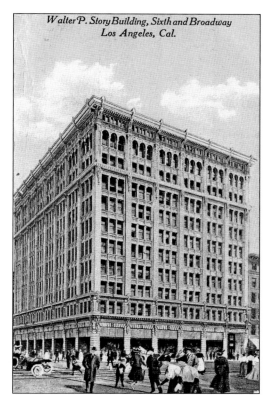

Walter P. Story Building, Sixth and Broadway Los Angeles, Cal.

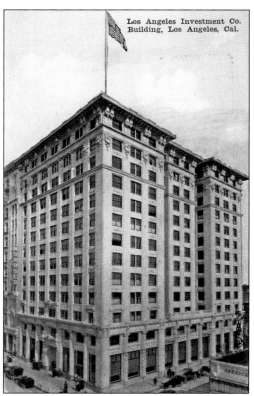

Los Angeles Investment Co. Building, Los Angeles, Cal.

Shown here is the Los Angeles Investment Company Building, constructed in 1912 at Broadway and Eighth Street. The office building was renamed the Chapman Building when it was purchased in 1920 by Charles Chapman, a wealthy citrus entrepreneur and the first mayor of Fullerton.

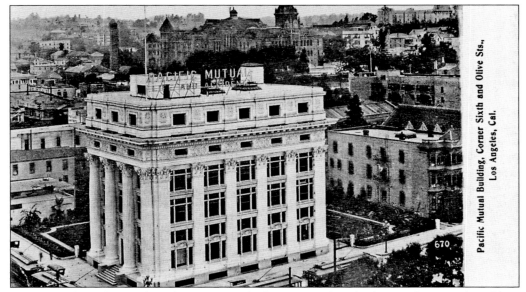

Constructed at Olive and Sixth Streets overlooking Central Park, the Pacific Mutual Building was in 1908 one of the first large business structures to locate in what had been a neighborhood of residences, apartment buildings, churches, and schools. The new structure served as the headquarters of Pacific Mutual Life Insurance Company, originally located in Sacramento. Founded in the 1860s, this was the first life insurance company in the West. Visible in the background is the State Normal School, later demolished to provide a site for the Los Angeles Public Library. To the right of the Pacific Mutual Building is the edge of St Paul's Cathedral, soon to be razed for the Biltmore Hotel.

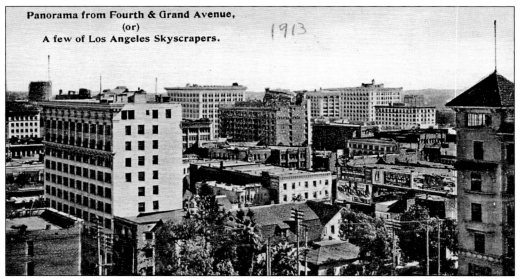

Panorama from Fourth & Grand Avenue,
(or)
A few of Los Angeles Skyscrapers.

This panoramic view, taken from Grand Avenue and Fourth Street, shows on the skyline a number of the new large office blocks pushing the business district of the city south. In the foreground are a few remaining residences. The pointed tower on the immediate right belongs to the Hotel Fremont, one of the many hotels and rooming houses that had begun to replace the single-family homes of the once-exclusive Bunker Hill neighborhood.

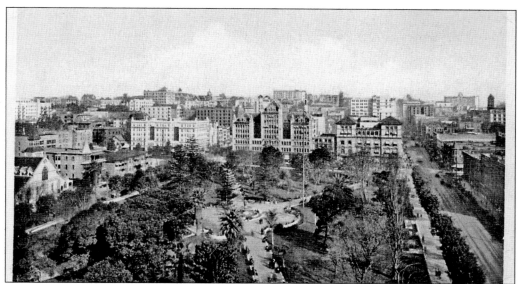

These two postcards, both facing north over Central Park, show the dramatic changes that occurred in the neighborhood in less than 20 years as the business district boomed. In the early-1910s image above, the neighborhood is composed primarily of apartment and rooming houses, with only a few small businesses. Several churches remain, such as St. Paul's Cathedral on the far left. The tower of the 1888 city hall on Broadway is visible over the low skyline at extreme right. Below, in the early 1930s, the neighborhood is at the heart of the business district, with imposing new structures now obscuring the view of Bunker Hill and Broadway. The Biltmore Hotel (left) replaced St. Paul's in 1923. The finest in the city, the hotel was a major reason for the neighborhood's increased popularity. Another reason was the 1925 construction of the Subway Terminal Building, partly visible just behind the Auditorium (center). Pedestrian traffic from the Pacific Electric streetcars that used the terminal caused the neighborhood to become one of the busiest in the city. The tall structure next to the Auditorium is the Title Guarantee and Trust Company Building, an office building constructed in 1931 on the site of the California Club building, seen above.

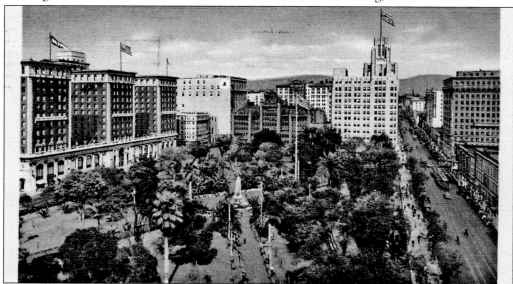

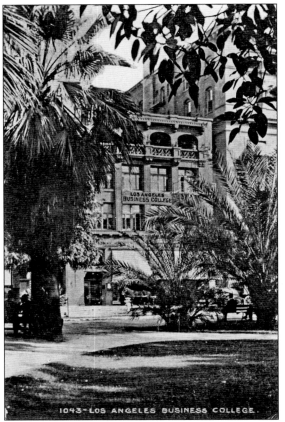

1043-LOS ANGELES BUSINESS COLLEGE.

Shown here is the Los Angeles Business College, located for many years in the Central Park neighborhood. Founded in 1882, this small building overlooked the park from its location on Fifth Street between Hill and Olive Streets, nestled between the California Club on the right and the Auditorium on the left.

This is the third home of the California Club, constructed on Fifth and Hill Streets in 1904. A private social club founded in 1887, the California Club boasted of a powerful membership list that included many of the city's most prominent business and civic leaders. In 1930, to keep pace with the southward expanding business district, the California Club moved to the more spacious quarters of its current location, next to the Los Angeles Public Library on Flower Street.

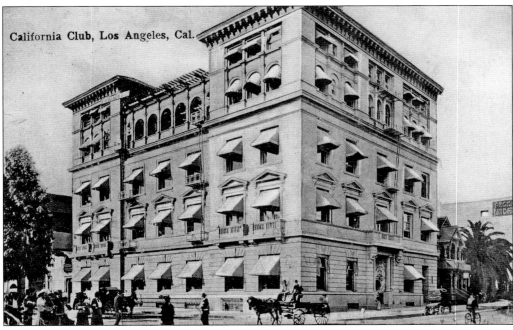

California Club, Los Angeles, Cal.

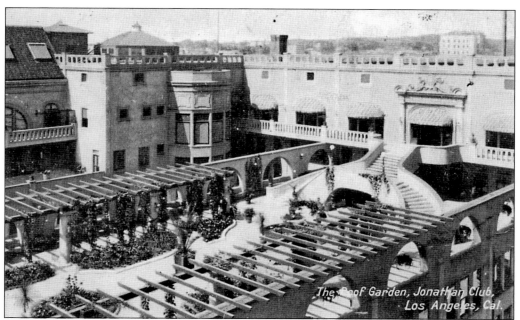

The Roof Garden, Jonathan Club, Los Angeles, Cal.

In 1894, a group of young men organized to campaign for William McKinley's presidential bid. They called themselves the Brother Jonathans, a patriotic reference to Jonathan Trumbell, a Colonial governor who supported the Revolutionary War by providing advise and supplies to Gen. George Washington. After McKinley's election, the group decided to continue meeting as a private social club, incorporating as the Jonathan Club in 1895. Shown here is the roof garden of the club's headquarters in the Pacific Electric Building, where it occupied the top two floors from 1905 to 1925. Henry Huntington, who constructed the building and used the ground level as the terminal for his Pacific Electric streetcar system, served as the club's president from 1904 to 1916.

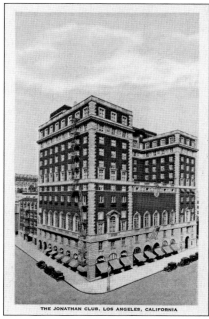

THE JONATHAN CLUB, LOS ANGELES, CALIFORNIA

Composed of some of the city's most prominent businessmen, the Jonathan Club was known for the entertainment events it hosted, as well as for the role its members played in city growth and business advancements. In 1924, having outgrown the space in the Pacific Electric Building, the club began construction on a new building, pictured here. Located at Figueroa and Sixth Streets, this structure has served as the club's headquarters since 1925.

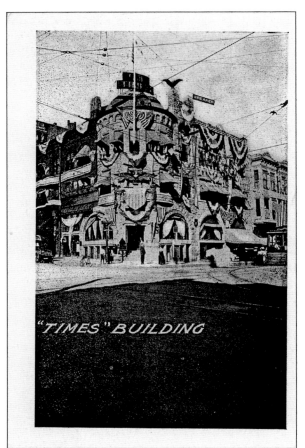

"TIMES" BUILDING

The *Los Angeles Times*, founded in 1881, spent its first years operating from a small building at Temple and New High Streets. In 1882, after encountering financial problems, the paper's printer, the Mirror Company, hired recent Los Angeles arrival Harrison Gray Otis as editor. Otis not only made the paper a success, he gained financial control of both the paper and the printing company, forming the Times Mirror Company. In 1886, at a time when there were few businesses in the area and Broadway was still an unpaved road known as Fort Street, Otis chose Broadway and First Street as the site for the newspaper's new home.

In 1910, the Los Angeles Times Building seen in the previous image was bombed by union agitators in response to the newspaper's anti-union stance. The *Los Angeles Times* constructed the new building seen here at the same location of Broadway and First Street. The large Hall of Records is visible on Broadway in the background.

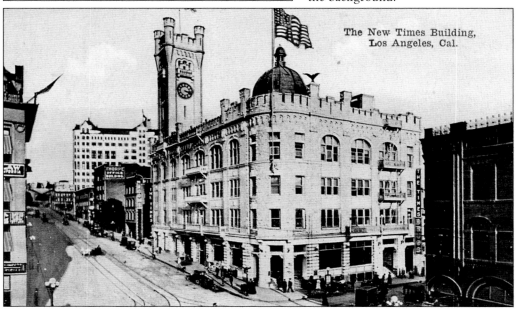

The New Times Building, Los Angeles, Cal.

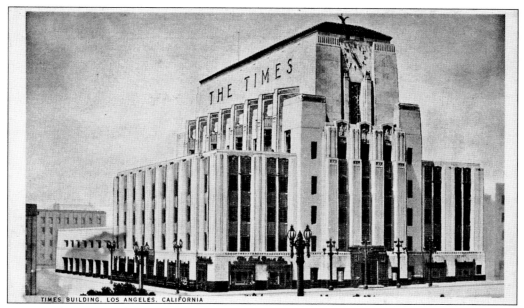

In 1935, the *Los Angeles Times*, now published by Otis's son-in-law Harry Chandler, relocated to a larger home at Spring and First Street. Adjacent to the new civic center, the $4-million structure housed the newspaper's printing presses, powered by their own private power plant.

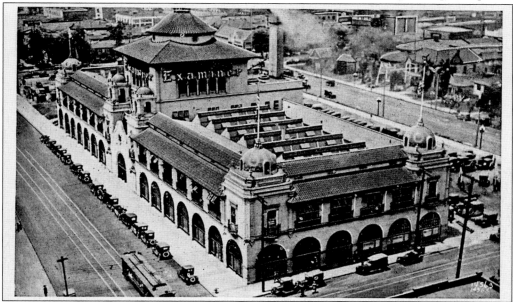

Founded in 1903 by William Randolph Hearst, the *Los Angeles Examiner* operated from offices on Broadway near Fifth Street until 1914, when the structure shown here at Broadway and Eleventh Street was completed. Designed by Julia Morgan, California's first licensed female architect, the building housed the newspaper's entire operations, including the printing presses. Hearst soon acquired two of the city's other newspapers, the *Herald* and the *Express*, which he merged in the 1930s as the *Herald Express*. The morning *Examiner* and the afternoon *Herald Express* were published until 1962, when the two were combined as the *Herald Examiner*.

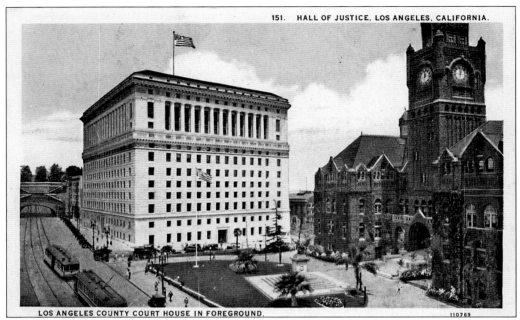

151. HALL OF JUSTICE, LOS ANGELES, CALIFORNIA.

LOS ANGELES COUNTY COURT HOUSE IN FOREGROUND.

110769

By the early 1920s, plans were underway for a new modern civic center to be constructed with coordinated city, state, and federal buildings. The Hall of Justice, seen here at Broadway and Temple Street next to the courthouse, was in 1925 the first of the planned buildings to be completed.

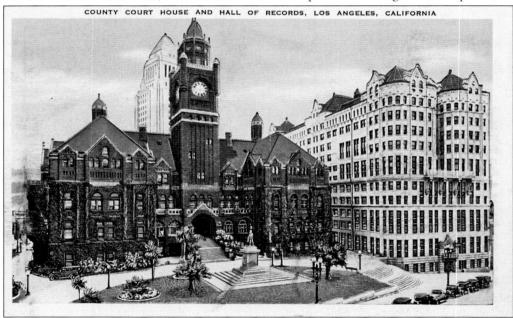

COUNTY COURT HOUSE AND HALL OF RECORDS, LOS ANGELES, CALIFORNIA

This postcard shows the Broadway entrance of the courthouse and Hall of Records, with the new Los Angeles City Hall towering just behind. The large statue on the courthouse lawn is of Stephen M. White, a prominent Los Angeles businessman who served in both the state and U.S. Senates. The 1908 statue was relocated to overlook the San Pedro harbor after the courthouse was demolished in 1936.

58

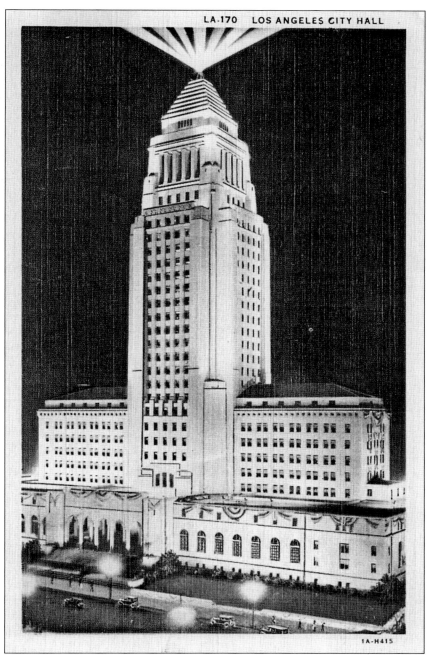

1A-H415

Los Angeles City Hall, completed in 1928, was designed by architects John Parkinson, John Austin, and Albert Martin. At 32 stories and 464 feet, the building was the tallest in the city and was topped by an airplane beacon named after Charles Lindbergh. During city hall's opening ceremonies, President Coolidge in the White House pressed the button that first illuminated the beacon across the Los Angeles sky. Far exceeding the height limit of 150 feet that had been in place since 1906, this landmark obtained special permission to be constructed. On the 25th floor was an observatory from which the public could view a panorama of the city.

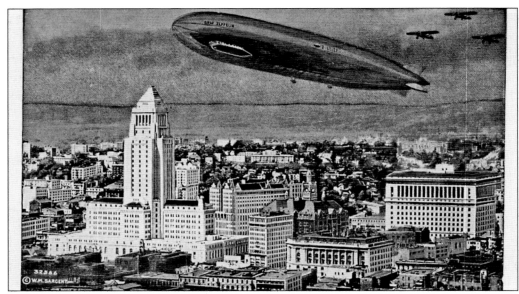

This postcard depicts the *Graf Zeppelin* flying over the Los Angeles Civic Center. Though this image was more than likely artificial, created for publicity purposes, the Zeppelin did actually visit the city in 1929. It landed near the current Los Angeles airport after completing the first nonstop flight across the Pacific Ocean as part of its around-the-world tour. The old courthouse with its clock tower is visible in the civic center, with the Hall of Records to its left. The buildings immediately to the right of the new city hall, in front of the courthouse, are the International Savings Bank and the 1908 post office, remnants of the old business district that would soon be demolished. At far right is the Hall of Justice.

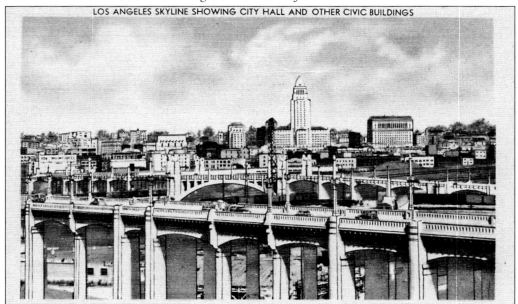

This mid-1930s view looks west toward the Los Angeles skyline from the bridges spanning the Los Angeles River. City hall is the standout of the new civic center, with the Hall of Justice on its right and the California State Building at its left.

The third structure to be finished in the new civic center was the California State Building, shown here next to city hall. Opened in 1933 on First Street between Broadway and Spring Street, the 12-story building served as the southern headquarters of the state's administrative offices.

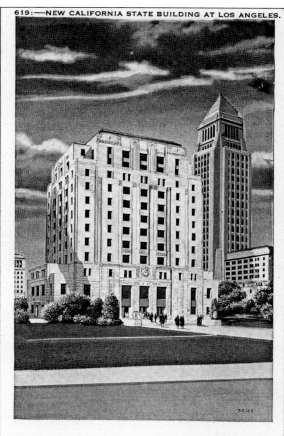

619:——NEW CALIFORNIA STATE BUILDING AT LOS ANGELES.

This view is of the Los Angeles Civic Center in the late 1930s. Three structures of the planned center have been completed: city hall at right, the California State Building in the left foreground, and the Hall of Justice in the left background. The earlier Hall of Records still stands at left middle, although the old courthouse has been demolished. The fourth civic center building, the federal building, would be added in 1939 on the other side of city hall.

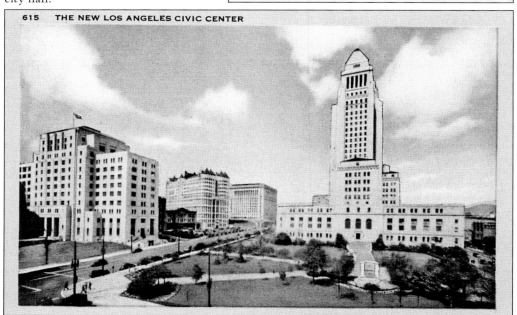

615 THE NEW LOS ANGELES CIVIC CENTER

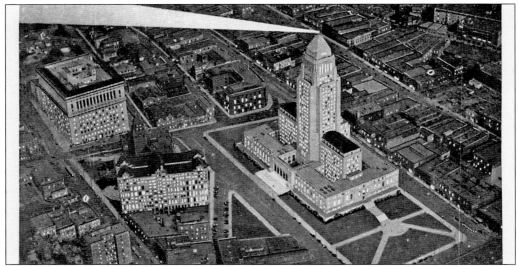

This early-1930s view provides an overview of the semi-completed civic center. City hall is at center, bounded by Spring and Main Streets to the left and right, First Street at bottom right, and Temple Street to the north. To the right of the Hall of Justice, at top left, are the two blocks soon to be demolished for the new federal building. The curved building at the edge of the two blocks, on Main and Temple Streets, is the old post office. Across from city hall is the old courthouse and the Hall of Records. As a result of the realignment of Spring Street that had occurred by this time, the small portion of street in front of the Hall of Records shows all that remains of New High Street, which originally continued across the corner of city hall's lawn to Temple Street. The old alignment of Spring Street would have run diagonally from First Street, seen in the immediate foreground, across the site of city hall, converging with Main Street at the old post office.

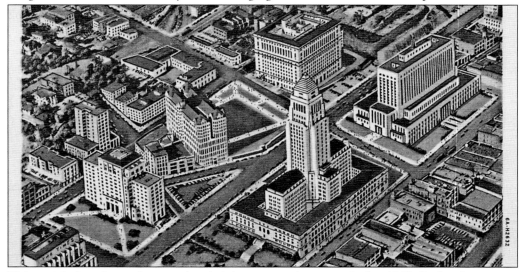

This aerial view shows the completed civic center as it appeared after 1939. Spring Street runs through the middle of the image, with city hall and the new federal building on the right side of the street and the California State Building, Hall of Records, and Hall of Justice on the left side. The open lawn between the Hall of Records and the Hall of Justice is where the old courthouse once stood.

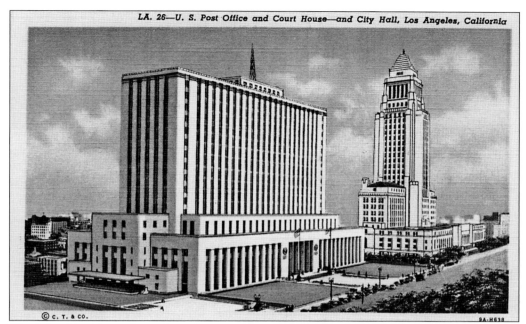

LA. 26—U. S. Post Office and Court House—and City Hall, Los Angeles, California

The federal building, shown here from its Spring Street entrance, was completed in 1939 as the fourth structure in the new civic center. The new building, which housed the post office and the federal courts, replaced the smaller post office and federal building that had been located on the site from 1908 to 1937.

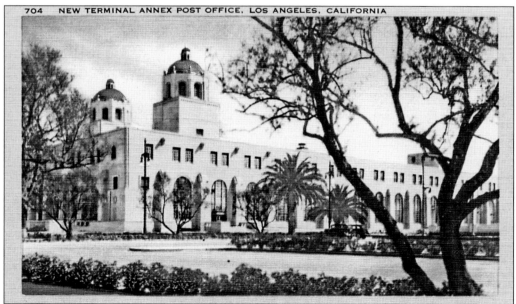

704 NEW TERMINAL ANNEX POST OFFICE, LOS ANGELES, CALIFORNIA

The Terminal Annex Post Office was constructed in 1938 on Alameda Street next to Union Station. Designed by Gilbert Stanley Underwood, the building served as the city's central mail distribution and processing center. The caption on the reverse of this 1940s postcard notes that the towers of the Mission-style structure are "exact replicas of those of the Basilica of Guadalupe in Mexico City."

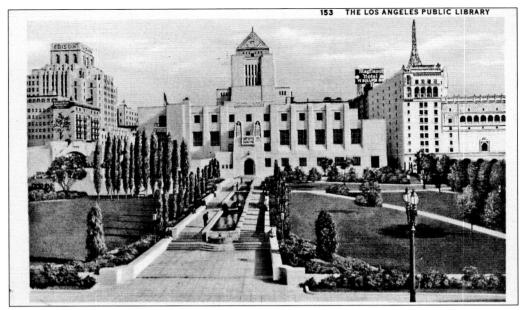

In 1926, more than 50 years after the Los Angeles Library Association was founded in 1872, the Los Angeles Public Library was finally housed in its own building. Located on the site of the old State Normal School, the new library was bounded on the north by Fifth Street and on the east by Grand Avenue. The library is shown from its Flower Street entrance, with the Edison Building to the left and the Bible Institute on the right.

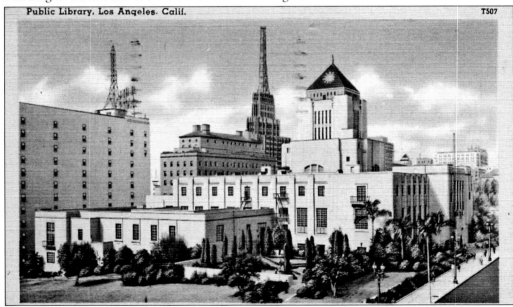

Designed by Bertram Goodhue, the Los Angeles Public Library was surrounded by landscaped lawns and tiled pools. The pyramidal roof of the building was decorated with Spanish tiles in a mosaic of geometrical designs. This view, taken from Fifth Street and Grand Avenue, shows the library and its neighbors, from left to right: the Bible Institute, the California Club, and the tall spire of the Richfield Oil Building.

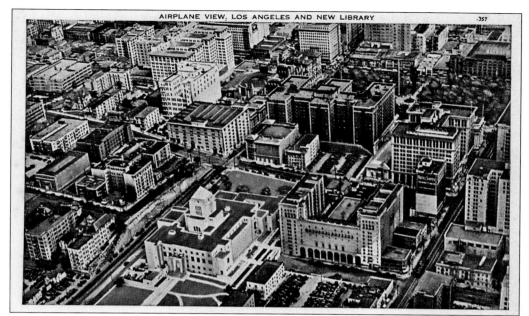

This postcard shows an aerial view looking east over the Los Angeles Public Library. To the right of the library is the Bible Institute. Near top right is Pershing Square, overlooked by the Biltmore Hotel as it appeared prior to 1928. At this time, an addition was constructed that extended the hotel to Grand Avenue, just across the street from the library grounds.

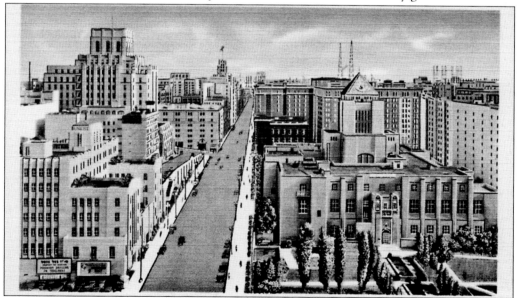

This later view faces east along Fifth Street from Flower Street, showing the Los Angeles Public Library on the right. At left, the smaller buildings seen in the previous image have been replaced by the Sunkist Building, in the foreground, and by the Edison Building, the tallest building on the left. The Sunkist Building, completed in 1935, served as the headquarters of the California Fruit Growers Association, which was active in promoting the sale of Southern California agriculture to the rest of the country.

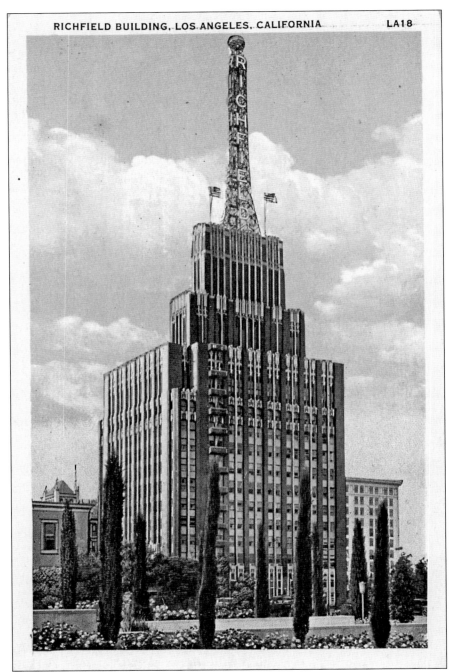

The Richfield Oil Building, designed by Morgan, Walls, and Clements, was constructed in 1929 at Flower and Sixth Streets, just across from the library. The building featured black terra-cotta accented with gold strips, a color scheme meant to symbolize the black gold wealth acquired in the company's oil fields. Special permission was granted for the steel sign tower to be placed on top of the building. In 1967, following the 1966 merger with Atlantic Oil Company, the building was demolished and replaced with the twin 52-story towers of the Arco Plaza.

Completed in 1931, the Edison
Building at Fifth Street and Grand
Avenue housed the Southern California
Edison Company, one of the largest
hydroelectric companies in the world.
The caption on the postcard's reverse
boasts, "This is an all electric building,
with electric heat, refrigeration, air
conditioning, time service, and modern
lighting." Floodlights illuminated
the building's exterior at night.
The building is now known as One
Bunker Hill.

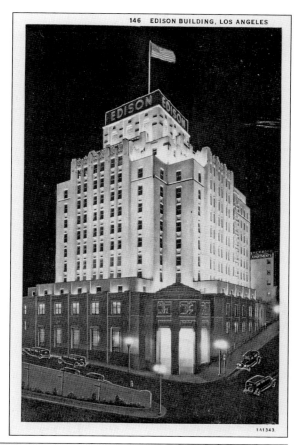

This real–photo postcard shows the
view from the observation deck of
Los Angeles City Hall in the 1930s.
Looking southwest, the burgeoning
business district of height-limited
buildings extends into the distance.
In the foreground is the Los Angeles
Times Building, completed in 1935
at Spring and First Streets. The tall
building with the spire just right
of center at the top is the Richfield
Oil Building.

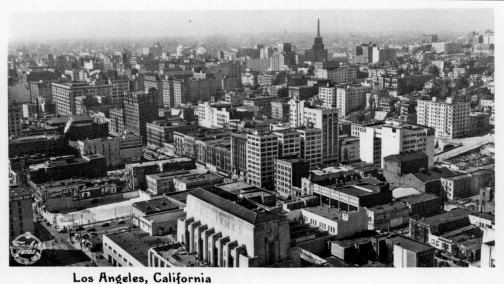

Los Angeles, California
from the Top of the City Hall Tower

B9611

67

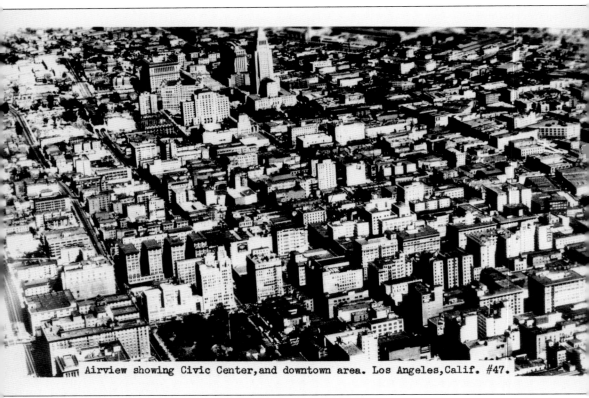

Airview showing Civic Center, and downtown area. Los Angeles, Calif. #47.

This real–photo postcard provides an aerial view of downtown Los Angeles as it appeared in the early 1940s. Facing north over the city from Sixth Street, the completed civic center appears just left of center at the top of the image. In the foreground is Central Park, now renamed Pershing Square, overlooked from its north side by the Auditorium and the Title Guarantee and Trust Building and from its west side by the Biltmore Hotel.

Three

TRANSPORTATION

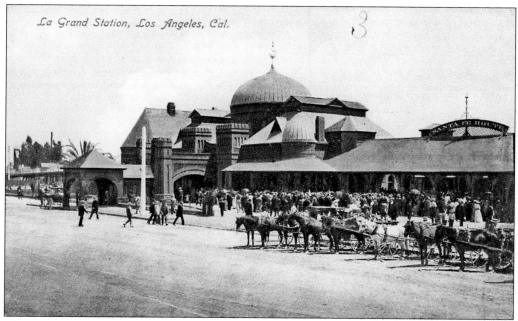

La Grand Station, Los Angeles, Cal.

This postcard shows La Grande Station, the passenger terminal constructed by the Santa Fe Railroad in 1893 on Santa Fe Avenue between First and Second Streets. The Santa Fe first reached Los Angeles in 1885, sparking a hearty rate competition with the Southern Pacific Railroad, who in 1876 had been the first to provide a transcontinental rail connection to the city. The low prices spurred a real estate boom and unprecedented population growth throughout the region as a massive influx of new residents and tourists began arriving.

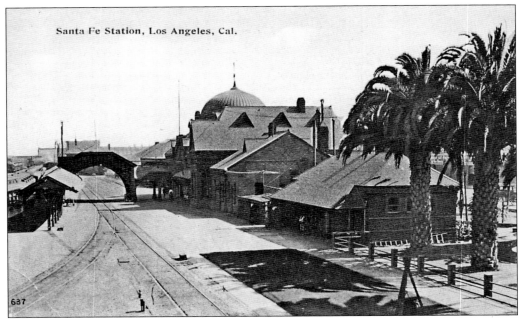

Santa Fe Station, Los Angeles, Cal.

La Grande Station was used by the Santa Fe Railroad from 1893 until Union Station was completed in 1939. Following damages incurred by the Long Beach earthquake in 1933, the large dome over the main passenger terminal was removed. In 1900, a Harvey House restaurant was opened to serve the station's passengers. Located at dining stops along the entire Santa Fe route, Harvey Houses were developed by Fred Harvey in the 1870s to provide railway travelers with quality food and friendly service.

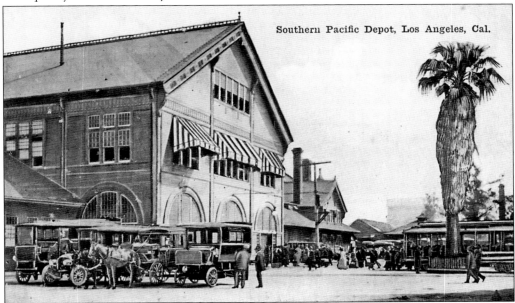

Southern Pacific Depot, Los Angeles, Cal.

The Arcade Depot was constructed in 1888 as the passenger terminal of the Southern Pacific Railroad. The Southern Pacific was the first railroad to provide a transcontinental connection to Los Angeles, via a southern extension from San Francisco completed in 1876.

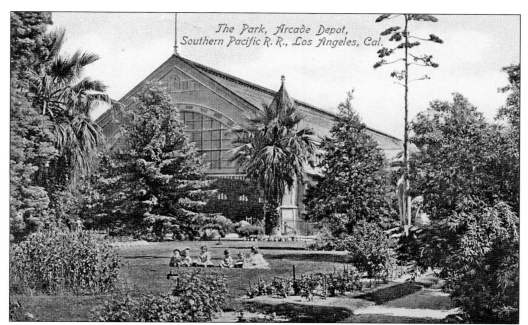

Shown here are some of the grounds surrounding the Arcade Depot. Located on Alameda Street between Fourth and Fifth Streets, the 60-acre property was given to the Southern Pacific by the city as part of a deal to lure the railroad to construct its southern extension through Los Angeles, rather than through an easier Mojave Desert route. In addition to the land for the depot, Southern Pacific also demanded that the city hand over an existing set of tracks between downtown Los Angeles and San Pedro.

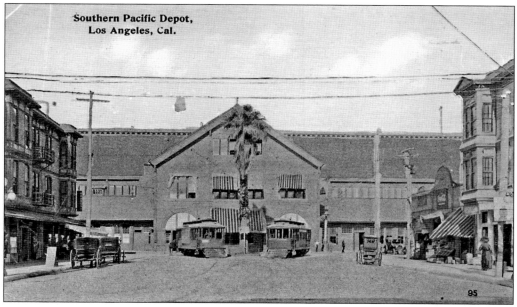

This 1914 postcard provides another view of the Arcade Depot. The Southern Pacific route to Los Angeles remained the only transcontinental passage until 1885, when the Santa Fe Railroad completed its track.

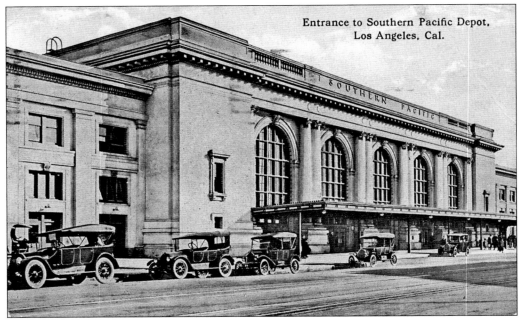

In 1914, the Southern Pacific constructed a new depot in downtown Los Angeles known as Central Station. Larger and more modern, the new passenger terminal occupied the same site as the now-demolished Arcade Depot, on Alameda Street between Fourth and Fifth Streets.

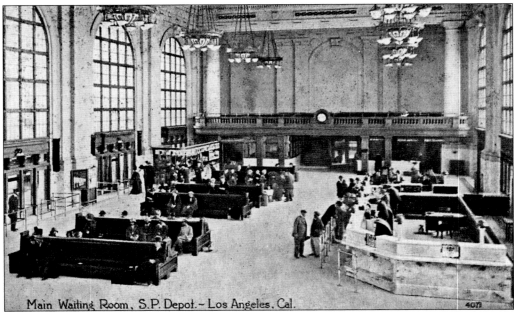

Shown here is the main waiting room in Central Station. This station was used until 1939, when services were moved to Union Station. Constructed as a joint effort of the Southern Pacific, the Santa Fe, and the Union Pacific, Union Station would provide a single terminal for the passenger services of all three major railroads.

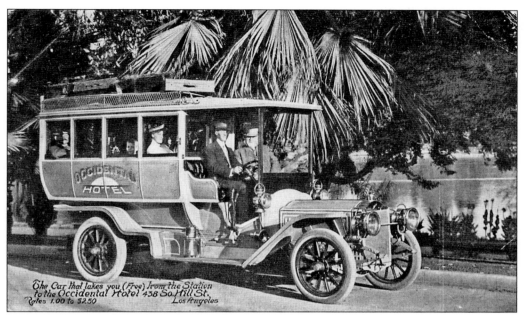

The Car that takes you (Free) from the Station to the Occidental Hotel 438 So. Hill St. Rates 1.00 to $2.50 Los Angeles

Many of the city's leading hotels provided cars to transport arriving travelers from the train station to their hotel for free. As tourism surged beginning in the mid-1880s, postcards advertising this service, such as the one pictured here from the Occidental Hotel, were distributed to attract guests.

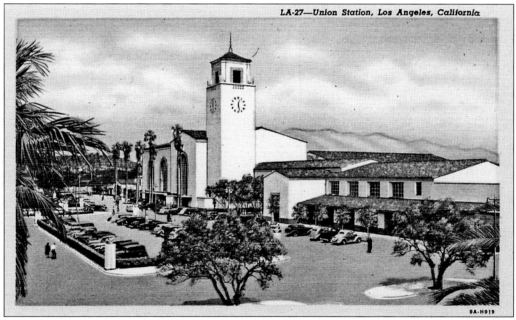

LA-27—Union Station, Los Angeles, California

Union Station was completed in 1939 as the new home for the city's three major railroads: the Southern Pacific, the Santa Fe, and the Union Pacific. The three had begun planning for a grand station in the early 1930s, combining their resources to fund the construction. Designed by John Parkinson and his son Donald Parkinson, the station was built on Alameda Street, near the new civic center and not far from the old Plaza.

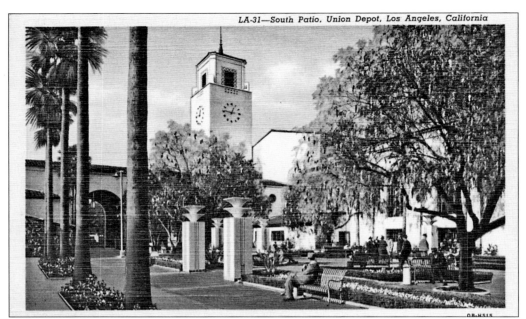

This postcard depicts Union Station's South Patio, an outside waiting area. Landscaped to showcase the diversity of the Southern California natural world, the patio featured palm trees, pepper trees, and olive trees. The patio is overlooked by the distinctive 135-foot-tall clock and observation tower.

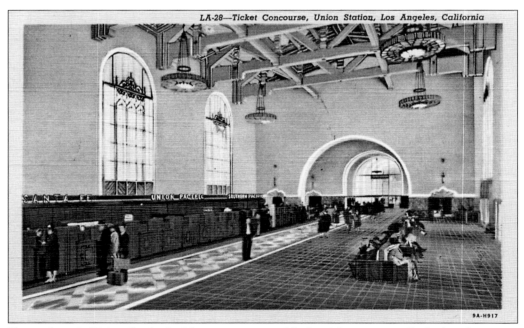

Shown here is Union Station's ticket concourse, with the ticket counter displaying the names of the three railroads that operated from the station. From left to right are the Santa Fe, Union Pacific, and Southern Pacific. Visible are the arched windows, marble floors, and high ceilings that were hallmarks of the station interior.

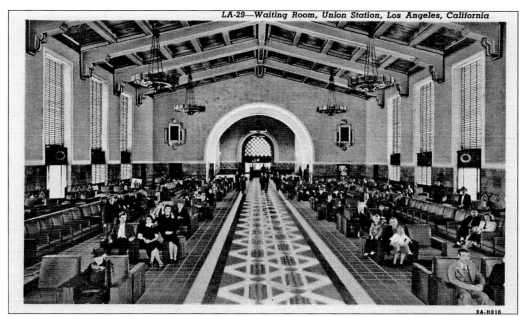

This postcard shows Union Station's waiting room, where passengers awaited their train on leather-upholstered chairs. The station, built near the end of the golden age of rail travel, saw one last boom in ridership during World War II before the automobile and airplanes eclipsed trains as the favored means of travel and transportation.

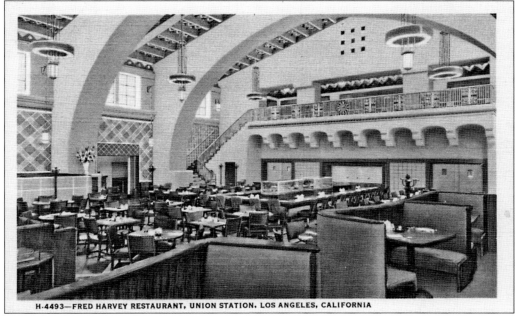

H-4493—FRED HARVEY RESTAURANT, UNION STATION, LOS ANGELES, CALIFORNIA

The Fred Harvey restaurant opened with Union Station in 1939. A chain of restaurants founded in the 1870s, Harvey Houses were known for providing railway passengers across the country with efficient, friendly service and quality, reasonably priced food. Los Angeles had been home to an earlier Harvey House, opened in 1900 in the Santa Fe Railroad's La Grande Station.

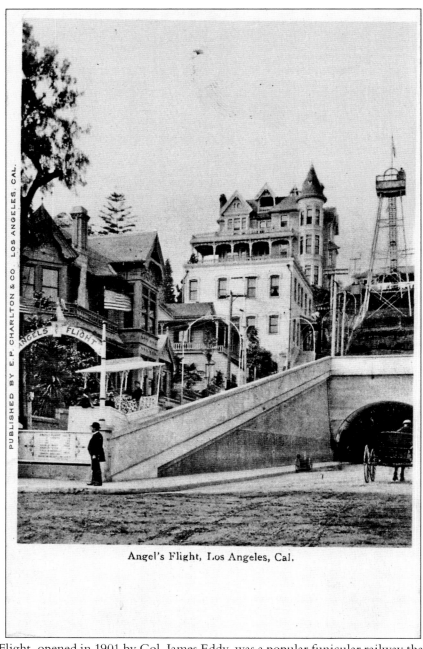

PUBLISHED BY E. P. CHARLTON & CO. LOS ANGELES, CAL.

Angel's Flight, Los Angeles, Cal.

Angels Flight, opened in 1901 by Col. James Eddy, was a popular funicular railway that carried passengers from the central shopping and business district to the residences on Bunker Hill. The railway, located next to Third Street, featured two cream-colored counterbalanced cars, named *Olivet* and *Sinai*. This pre-1905 view shows the railway as it originally operated, with the cars ascending from Hill Street, stopping halfway to cross the small alley known as Clay Street, and then continuing up the hill at a steeper grade to Olive Street. The 100-foot observation tower at the top of the hill was constructed by Eddy so that visitors could enjoy a panoramic overlook of the city. At the top of the hill is the Crocker mansion, constructed in 1881.

In 1905, Eddy reconstructed the Angels Flight track, adding a wooden trestle to enable the cars to pass over Clay Street and ascend the hill at a uniform grade. The new, larger, enclosed cars that appear here were also added in 1905. The new lodge of the Benevolent and Protective Order of Elks (BPOE) now stands at the top of the hill, constructed on the site of the Crocker mansion in 1908.

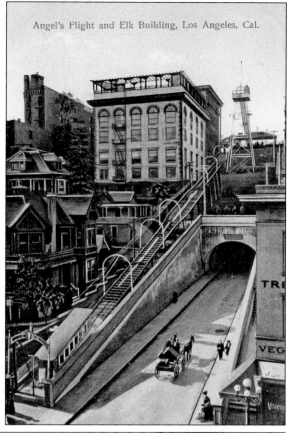

Angel's Flight and Elk Building, Los Angeles, Cal.

This view of Angels Flight, now surrounded by office buildings, shows the new archway at the Hill Street entrance, added in 1910 as a beautification effort. The letters BPOE were etched into the arch when the lodge donated money to the project. Eddy also constructed a matching colonnaded station house, seen at the top of the incline at the Olive Street entrance.

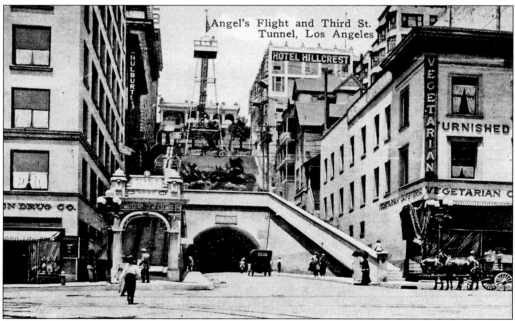

Angel's Flight and Third St. Tunnel, Los Angeles

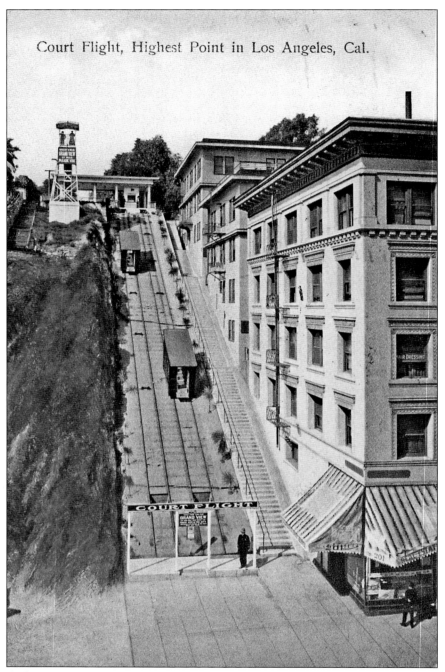

Court Flight, Highest Point in Los Angeles, Cal.

Court Flight opened in 1904 as the second funicular railway in downtown Los Angeles. Like its competitor, Angels Flight, the railway transported passengers from the business district to the residences on Bunker Hill. Located across from the old courthouse, midway between First and Temple Streets, the incline ascended the hill from Broadway to Court Street. At the top of the incline is an observation tower, known as the Grand View. Court Flight closed permanently after it was damaged by a fire in 1943.

The Pacific Electric Building, which housed the Pacific Electric's passenger depot, was constructed by Henry Huntington at Main and Sixth Streets in 1903. Huntington, the nephew of Southern Pacific president Collis Huntington, began his involvement in Los Angeles's mass transit system in 1898, when he bought into the Los Angeles Railway Company, an urban system operating mostly within the city limits. In 1901, Huntington incorporated a new company, Pacific Electric, and began building a massive network of interurban streetcar lines. Containing at its peak more than 1,000 miles of track throughout the region, it could transport passengers to Pasadena, Hollywood, the beaches, Orange County, San Bernardino, and more. In 1911, Southern Pacific gained control of Pacific Electric from Huntington, combining it with other local lines as part of the "Great Merger." The cars of the combined system, operated under the Pacific Electric name, were painted a uniform red color, leading them to be known as the "red cars." Huntington maintained control of the Los Angeles Railway, whose "yellow cars" enjoyed a higher ridership than the Pacific Electric ever did.

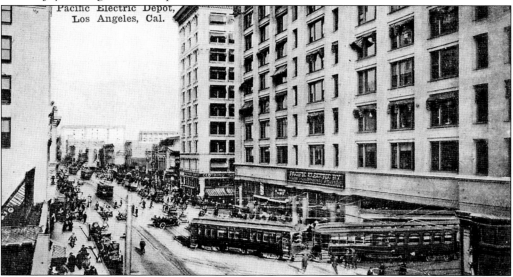

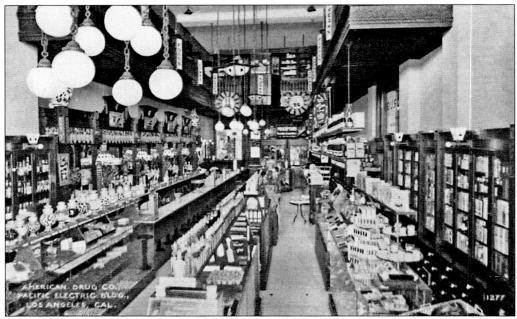

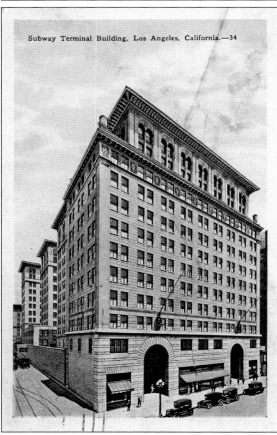

Subway Terminal Building, Los Angeles, California.—34

Shown here is the interior of the American Drug Company, one of the stores operating out of the Pacific Electric Building for the convenience of passengers waiting at the depot. Another corner of the building contained a restaurant named Cole's P. E. Buffet, still in operation. The depot waiting room also contained news and curio stands.

In 1925, the Subway Terminal Building opened as a second passenger terminal for the Pacific Electric system. Replacing the smaller Hill Street Station at Hill and Fourth Streets, near Pershing Square, the building served as the terminus for several Pacific Electric lines, primarily to Hollywood and the San Fernando Valley. The building, whose upper floors were leased as office space, was designed by Schultze and Weaver, the architects who had recently completed the nearby Biltmore Hotel. As indicated by the building's name, the new depot was also used by the city's one subway line. Originally intended to continue all the way to Hollywood, only one mile of the line was ever constructed.

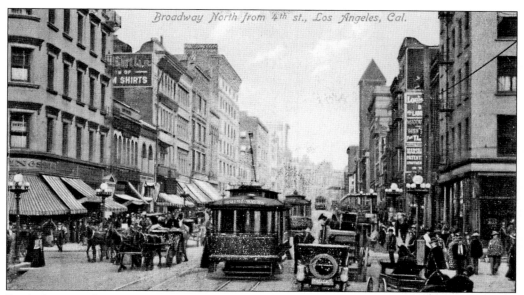

Depicting an early street scene on Broadway near Fourth Street, this postcard shows the changing modes of transportation in downtown Los Angeles. Visible are a few remaining horse and buggies, once the only means of transportation. As the city grew and streetcar lines were constructed, it became possible to live farther from the city center while still maintaining access to the employment, shopping, and entertainment that downtown offered. This trend was accelerated by the automobile, just beginning to appear in the image here. Gaining popularity at a rate not seen elsewhere, the automobile would in a matter of years dominate the streets of Los Angeles.

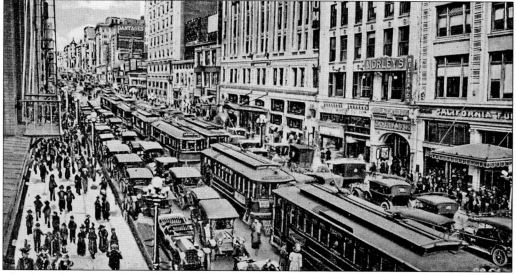

This later depiction of Broadway, facing north from Seventh Street in the early 1920s, shows how the proliferation of automobiles combined with the city's numerous streetcar lines to cause increasing traffic. Los Angeles acquired more cars per capita than any other city as car ownership among residents skyrocketed in the 1920s. An indication of the city's new metropolitan status, the author of this postcard writes in 1922, "Boston looks like a village when compared with this city."

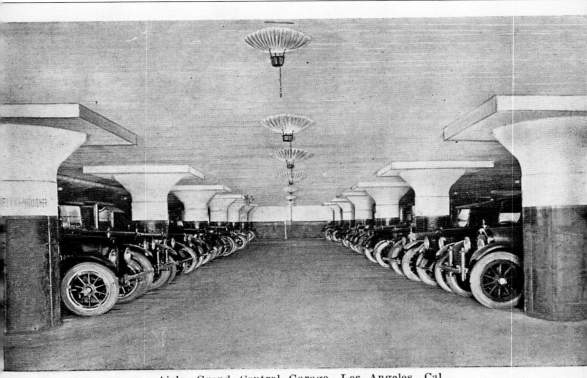

Aisle, Grand Central Garage, Los Angeles, Cal.

With so many automobiles crowding the streets, a new type of structure began to appear in downtown Los Angeles: the multilevel parking garage. This postcard depicts the Grand Central Garage, which contained over 1,000 parking spaces in a structure located near the Biltmore Hotel at Fifth Street and Grand Avenue. The caption on the reverse side boasts, "Each floor has its own gasoline and oil supply station as well as air and water service, with the exception of the ninth, which is occupied by the repair shop."

Four

HOTELS

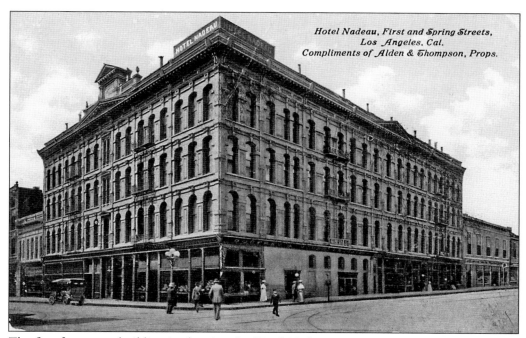

Hotel Nadeau, First and Spring Streets,
Los Angeles, Cal.
Compliments of Alden & Thompson, Props.

The first four-story building in the city, the Hotel Nadeau was constructed in 1882 by Remi Nadeau. Located at First and Spring Streets, the hotel was for many years regarded as the city's finest. The hotel was also the first to contain a passenger elevator. In 1935, the *Los Angeles Times* constructed its new headquarters on the site of the demolished hotel.

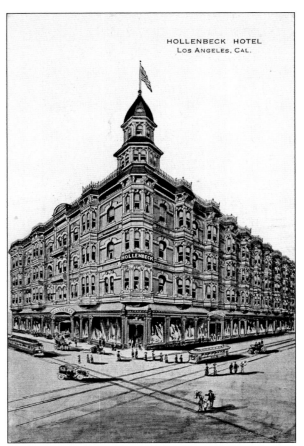

HOLLENBECK HOTEL
LOS ANGELES, CAL.

Shown here is the Hollenbeck Hotel, constructed in 1884 at Spring and Second Streets. The hotel was named for its owner, John Hollenbeck, a prominent investor, banker, and owner of large landholdings in the Boyle Heights area. A leading hotel in its day, it was designed by Robert Young, an architect responsible for several early downtown hotels, including the Lankershim, the Lexington, and the Westminster.

This postcard depicts the lobby of the Hollenbeck Hotel. In 1893, the hotel came under the proprietorship of Albert Bilicke, who maintained the hotel as one of the most popular for many years. In 1903, Bilicke joined with real estate investor Robert Rowan to create the Bilicke-Rowan Fireproof Building Company, which went on to construct the Alexandria Hotel. After it began to decline because of competition from newer hotels, the Hollenbeck was demolished in 1933.

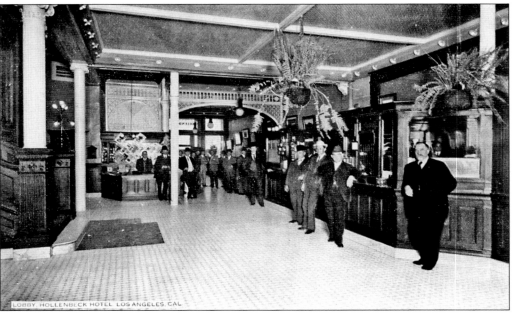

LOBBY, HOLLENBECK HOTEL, LOS ANGELES, CAL.

The Van Nuys Hotel, built in 1896, was designed by well-known Los Angeles architects Octavius Morgan and John Walls. Located at Main and Fourth Streets, the hotel was one of the finest. It was also the first to have telephones installed in every room. In the 1920s, the hotel's new owners changed the name to Hotel Barclay.

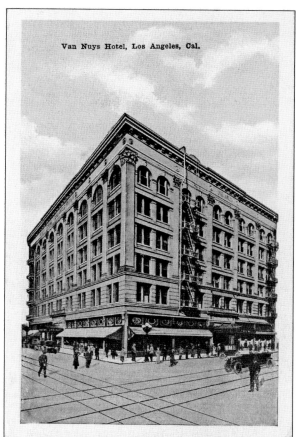

Van Nuys Hotel, Los Angeles, Cal.

Postmarked in 1910, this postcard depicts part of the lobby interior of the Hotel Van Nuys. The hotel was originally owned by Isaac Van Nuys, who, together with his father-in-law, Isaac Lankershim, at one point owned a substantial portion of the San Fernando Valley. Founders of an organization called the San Fernando Homestead Association, they implemented a huge wheat farming operation and owned a flour mill at Commercial and Alameda Streets. In 1911, part of the land was subdivided into residential lots, with the new town site bearing the name Van Nuys.

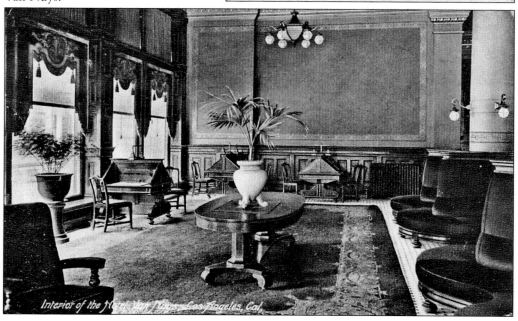

Interior of the Hotel Van Nuys, Los Angeles, Cal.

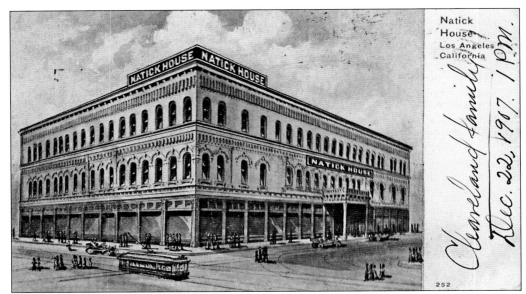

This postcard, postmarked in 1907, shows the Natick House, constructed in 1884 at Main and First Streets. The fashionable 80-room hotel boasted a central location across the street from the Grand Opera House. Purchased by H. A. Hart in 1890, the hotel continued to operate under the direction of his two sons following his death in 1892. The Hart brothers became well-known hoteliers when they began operating an additional hotel, the Hotel Rosslyn, purchased in 1903. The Natick House, originally a two-story hotel, gained a third floor and an elevator in 1899 as part of extensive renovations carried out that year.

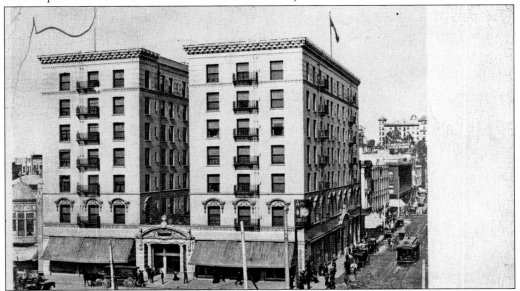

When the Angelus Hotel opened in 1901, it was the tallest structure in the city. Located at Spring and Fourth Streets, it was for several years the city's leading hotel. The hotel was designed by John Parkinson, who went on design numerous other downtown hotels, including the King Edward, the Alexandria, and the Hotel Rosslyn. Soon eclipsed in elegance by other hotels, the Angelus ended up being razed in 1956.

The Hotel Lankershim was constructed in 1905 at Broadway and Seventh Street, later one of the busiest intersections in the city. The hotel was owned by James Lankershim, whose father, Isaac, had been a major landowner in the San Fernando Valley beginning in the 1860s. Many hotels operated vehicles such as the one shown at top, providing transportation for guests between their hotel and the train depots.

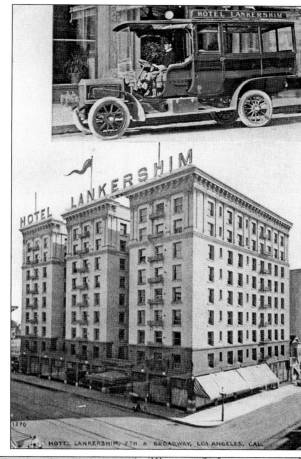

Postmarked in 1906, this postcard depicts the King Edward Hotel, located at Fifth and Los Angeles Streets. Written by a hotel guest, the postcard's message provides a glimpse into early tourism and the draw of the Southern California climate. She writes, "Here we are domiciled in Los Angeles. Our room is on first floor. Tomorrow will be spent quietly. We are in love with this weather. When we are old, we will come here to rest. This sunny warmth intoxicates one. We have not planned when we can leave, there is so much to see."

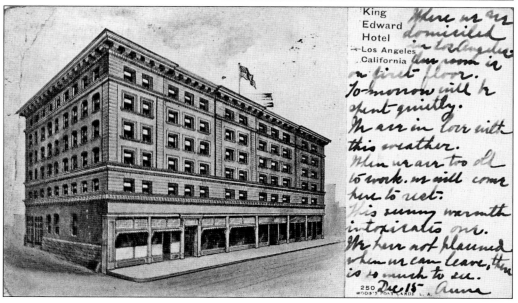

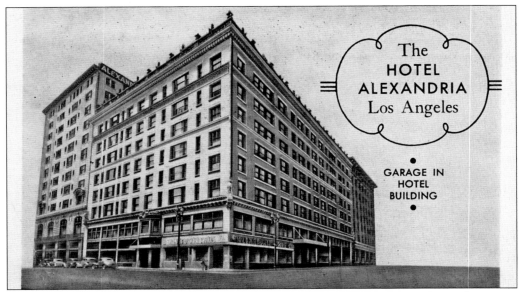

When the Hotel Alexandria opened in 1906, it was considered the finest and most luxurious hotel in the city. Located at Spring and Fifth Streets, the hotel was designed by John Parkinson and his partner G. Edwin Bergstrom. The popular hotel soon added two annexes, a small 60-room annex on Fifth Street and a larger 12-story annex on Spring Street. As noted on the postcard, the hotel contained a two-story underground parking garage.

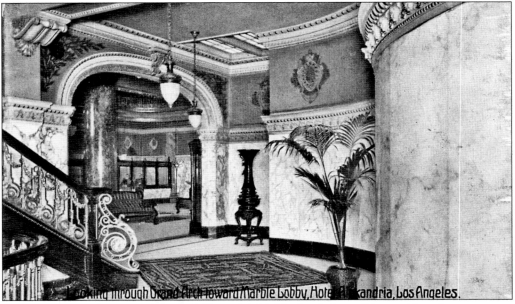

This 1908 postcard portrays the Hotel Alexandria's lobby level. One of the marble staircases appears at left, and through the archway is the hotel's ornate marble lobby. The Alexandria quickly became the hotel of choice for celebrities of the day, with the hotel's dining room ranking as a favorite spot for those involved with the burgeoning film industry to conduct business. In addition to the its movie star clientele, several dignitaries visited the hotel, including King Edward VIII of England, Winston Churchill, and U.S. presidents William Taft, Woodrow Wilson, and Theodore Roosevelt.

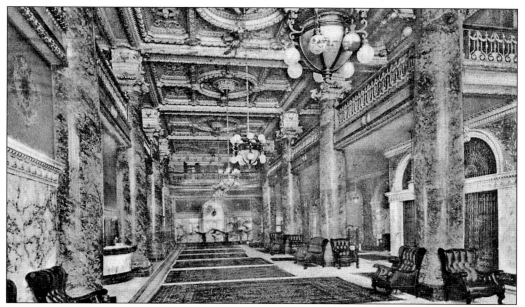

Postmarked in 1912, this postcard shows the Hotel Alexandria's grand lobby, which featured marble columns, 60-foot ceilings, and gold leaf. After the Biltmore Hotel was opened in 1923, the Alexandria began to decline, eventually going bankrupt in the early 1930s. The chandeliers and gold leaf were stripped and sold, and the hotel remained closed for several years. After undergoing remodeling, the hotel reopened in 1937, although it was never able to recover its former grandeur. The lobby was later divided in half when the mezzanine was closed in to create a second level. The original ornate ceiling seen in this image became the ceiling for this new level.

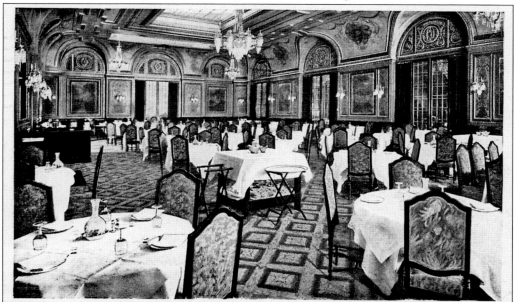

Shown here is the Franco Italian Dining Salon, one of the Hotel Alexandria's dining spots. Located just off the lobby, the dining room featured Tiffany stained-glass skylights. The room was later renamed the Palm Court.

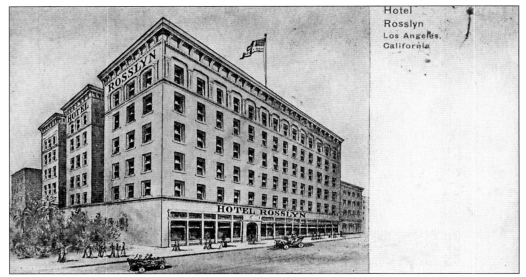

In 1903, the Hotel Rosslyn was purchased by George and Dwight Hart, owners of the successful Natick House at Main and First Streets. Located on Main Street between Fourth and Fifth Streets, the small hotel was soon expanded when the brothers purchased the adjacent Lexington Hotel. This postcard shows the Lexington Hotel addition, although this artist's rendering elongates the hotel to make it seem as though it extends much farther along Main Street than it actually did. The small building to the right is the original Hotel Rosslyn building.

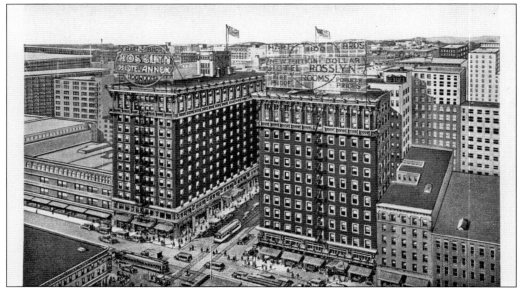

In 1913, the Hart brothers constructed a new 13-story Hotel Rosslyn on the corner of Main and Fifth Streets, shown here on the right with the famous sign on top that advertises the "New Million Dollar Hotel." Ten years later, they added a matching annex to the hotel, just across the street. The Lexington Hotel addition, the E-shaped building that adjoins the new main hotel on the right, was connected and continued to be used as part of the hotel. The grand total of rooms in all the Hotel Rosslyn buildings came to 1,100, making the hotel the largest in the city and one of the largest on the West Coast.

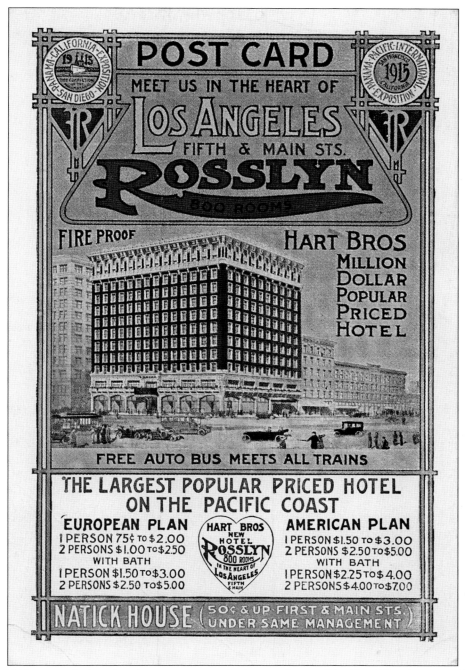

This 1915 postcard advertises the room rates and other attributes of the Hotel Rosslyn, completed in 1913 at the corner of Main and Fifth Streets. Before the 1923 annex, the hotel had contained 800 rooms. From the advertisements in the top two corners, the postcard appears to be geared at attracting tourists attending the state's two large events of the year: the Panama California Exposition in San Diego, which celebrated the opening of the Panama Canal, and the 1915 World's Fair in San Francisco, titled the Panama Pacific International Exposition.

New Hotel Rosslyn

FIFTH AND MAIN STREETS
LOS ANGELES, CAL.
HART BROS., PROPS.

DINNER 25C.

SOUP
Clam Chowder

RELISHES

| Horseradish | Pickles | Catsup |

FISH
Baked Baracuda

ENTREES
Short Ribs of Beef
Boiled Shoulder of Lamb, Caper Sauce
Spaghetti and Cheese
Boston Baked Beans

ROASTS AND STEAKS

Roast Beef Roast Pork Roast Mutton
Pork Chops Roast Lamb
 Small Beefsteak

VEGETABLES
Baked Potatoes Stewed Sweet Corn

DESSERTS

Apple Pie Pumpkin Pie Sago Pudding
 Vanilla Ice Cream and Cake
Coffee Tea Milk

This is the Best Meal on Earth for the Price
Yours truly,

This postcard advertises the Hotel Rosslyn's dinner menu. At a cost of 25¢, the postcard proclaims, "This is the best meal on Earth to be had for the price." Known for excellent food and reasonable prices, the hotel's large dining room was located on the mezzanine level of the main hotel.

Shown here is the Monterey Room, a bar and dining spot operated by the Hotel Rosslyn. The room was located in the 145-foot underground marble subway that connected the main hotel with the annex across the street. The caption on the reverse advertises, "Enjoy a tasty luncheon courteously served in a friendly atmosphere away from the noise of traffic."

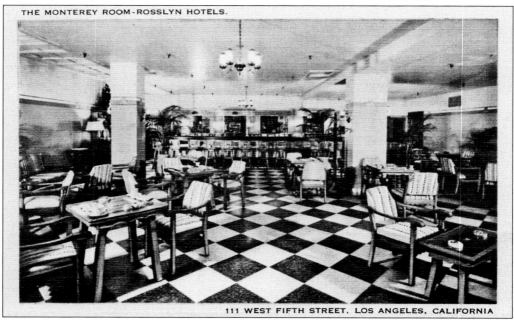

THE MONTEREY ROOM - ROSSLYN HOTELS.

111 WEST FIFTH STREET, LOS ANGELES, CALIFORNIA

The Hotel Stowell was constructed in 1913 on Spring Street between Fourth and Fifth Streets, in the heart of the city's financial district. This was the second downtown building to be constructed by financier and businessman Nathan Stowell; in 1889, he had opened the Germain Building, the first large modern office building south of Second Street. The striking facade of the 12-story hotel was composed of white terra-cotta and green glazed bricks.

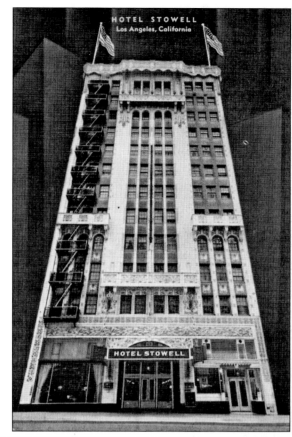

This postcard, postmarked in 1916, shows the lobby of the Hotel Stowell. Narrow but grand, the lobby featured a marble staircase and walls decorated with Batchelder tiles. The reverse of the postcard advertises that each room in the hotel comes with a private bath and running ice water.

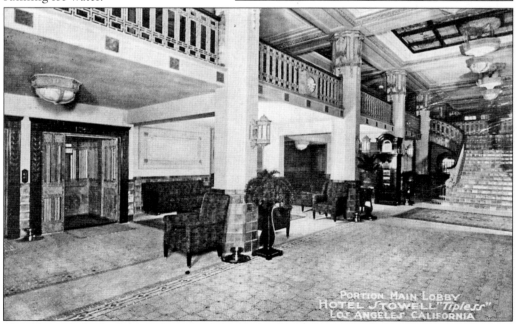

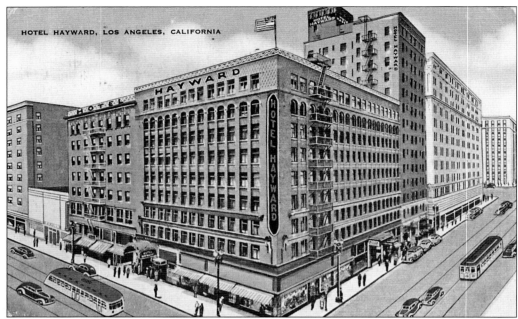

HOTEL HAYWARD, LOS ANGELES, CALIFORNIA

This 1940s postcard depicts the Hotel Hayward, constructed in 1905 at the corner of Spring and Sixth Streets. Convenient to the main financial and shopping districts, the comfortable and modestly priced hotel was successful enough to complete two additions: a 7-story addition on Spring Street in 1918 and a 14-story annex on Sixth Street in 1926.

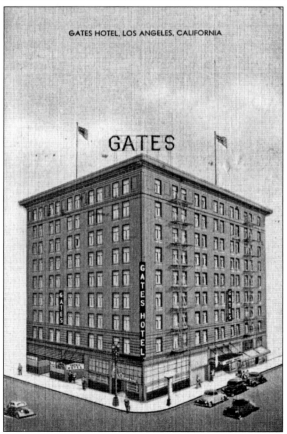

GATES HOTEL, LOS ANGELES, CALIFORNIA

The Gates Hotel was constructed in 1912 at Figueroa and Sixth Streets. Though located several blocks from the heart of the business and shopping district, the hotel nonetheless advertised that it was at the "center of everything." The caption on the postcard's reverse notes that the hotel contained 300 newly decorated rooms, each with a radio.

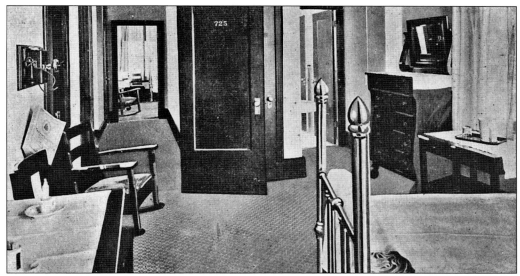

Shown here is the interior of Suite 725 at the Gates Hotel, demonstrating what a guest at the time could expect from his or her hotel room. The caption on the reverse advertises, "A room with a bath for a dollar and a half." This room's private bath is visible through the doorway by the dresser on the right. Many hotels, including this one, equipped their rooms with telephones; the phone in this room, complete with its own telephone directory, is mounted on the wall at the left of the image.

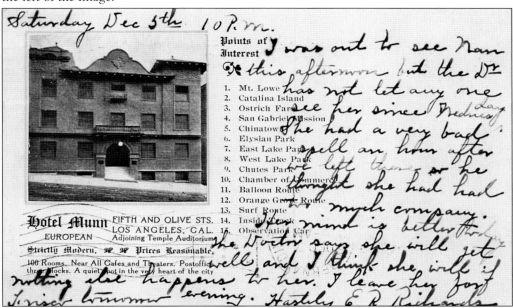

The Hotel Munn was located on Olive Street near Fifth Street, adjacent to the Auditorium and across the street from the Hotel Trenton. This 1908 postcard, which notes that the hotel's 100 rooms are located in the heart of the city, lists 15 local points of interest, including Mount Lowe, Catalina Island, the South Pasadena Ostrich Farm, and Chutes Park. Also listed are several of the popular sightseeing trips that carried tourists by streetcar to visit regional attractions, such as the Balloon Route, the Orange Grove Route, and the Seeing Los Angeles Observation Car.

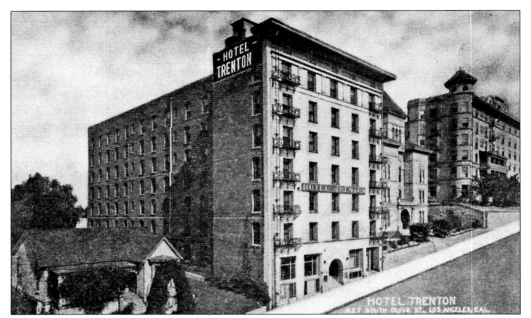

The Hotel Trenton was located on Olive Street between Fifth and Sixth Streets, half a block from the luxurious Biltmore Hotel. The hotel was part of the Bunker Hill district, once an exclusive residential neighborhood but now occupied primarily by a variety of hotels and rooming houses. One small residence remains to the left of the hotel. To the right of the hotel is the Olive Street School, and farther up the hill appears the Fremont Hotel.

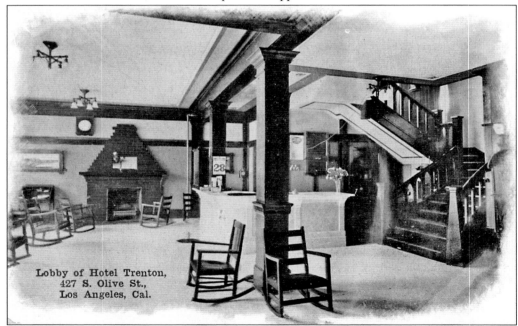

This postcard portrays the modest lobby of the Hotel Trenton. The rocking chair appears here as the furnishing of choice, a common feature seen throughout many hotel lobbies in the early 1900s.

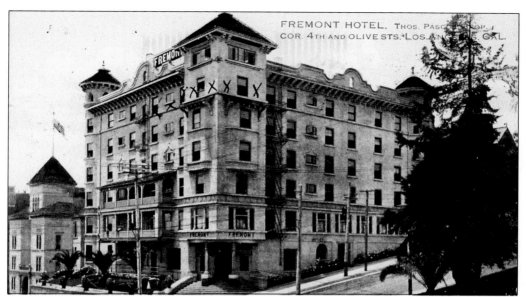

The Fremont Hotel was located in the Bunker Hill neighborhood at Olive and Fourth Streets. The hotel was just up the street from the Hotel Trenton, barely visible on the extreme left of the image. Between the two hotels is the Olive Street School. The hotel was designed by John Austin, later one of the partners involved in designing the 1928 Los Angeles City Hall. The authors of this 1912 postcard have marked their room, number 620, with Xs. They write, "We are glad to be back in this hotel. It seems like home to us now we have been here so long."

Like many of the Victorian mansions built on Bunker Hill in the 1880s, the Melrose mansion, seen at right in this 1907 image, began as a private residence. As families began moving away to more fashionable neighborhoods, many of the mansions became rooming houses or hotels. The Melrose mansion, constructed in 1881, spent several years as a rooming house before it became a hotel, with a new structure (left) added to accommodate additional guests. The two were connected, with the mansion serving as the hotel's annex.

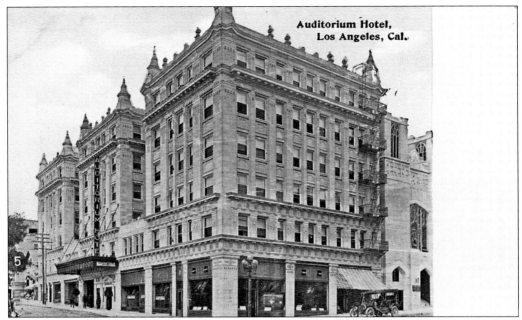

Auditorium Hotel,
Los Angeles, Cal.

The Auditorium Hotel was located at Olive and Fifth Streets, overlooking a corner of Central Park. Opened in 1911, the hotel's design mimicked the style of architecture used for popular entertainment venue the Auditorium, located directly across Olive Street. The hotel would soon be overshadowed when the Biltmore Hotel was constructed in 1923 just across Fifth Street. The hotel was renamed the San Carlos Hotel in 1929.

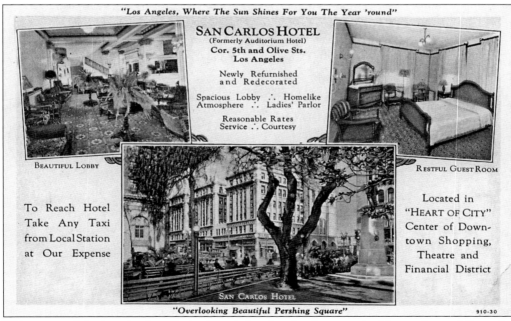

"Los Angeles, Where The Sun Shines For You The Year 'round"

SAN CARLOS HOTEL
(Formerly Auditorium Hotel)
**Cor. 5th and Olive Sts.
Los Angeles**

Newly Refurnished
and Redecorated

Spacious Lobby ∴ Homelike
Atmosphere ∴ Ladies' Parlor

Reasonable Rates
Service ∴ Courtesy

BEAUTIFUL LOBBY

RESTFUL GUEST ROOM

To Reach Hotel
Take Any Taxi
from Local Station
at Our Expense

Located in
"HEART OF CITY"
Center of Downtown Shopping,
Theatre and
Financial District

SAN CARLOS HOTEL

"Overlooking Beautiful Pershing Square"

910-30

This postcard depicts the San Carlos Hotel shortly after its name had been changed from the Auditorium Hotel. Advertising the hotel's location in the heart of the city, this postcard presents images of its lobby and of a guest room.

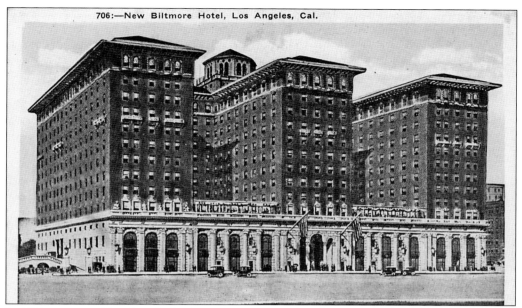

706:—New Biltmore Hotel, Los Angeles, Cal.

In 1921, a group of Los Angeles businessmen, concerned with the city's lack of a truly grand hotel, formed the Central Investment Corporation to plan and finance the construction of a worthy hotel. The site chosen was on Olive Street between Fifth and Sixth Streets, overlooking Pershing Square. The impressive result, the Biltmore Hotel, opened in 1923 with an inaugural banquet and ball, as the city celebrated its new status as home to the finest and largest hotel west of Chicago.

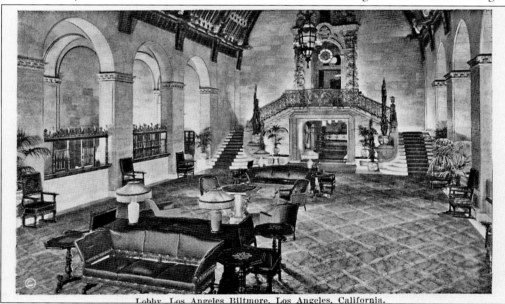

Lobby Los Angeles Biltmore, Los Angeles, California.

Shown here is the grand lobby of the Biltmore Hotel, accessed from the hotel's main entrance on Olive Street. The hotel, designed by New York architects Leonard Schultze and S. Fullerton Weaver, featured an exterior of red brick, cream-colored stone, and white terra-cotta trim. The original E-shaped structure contained nearly 1,000 rooms, increased to 1,500 when a 500-room addition extending to Grand Avenue was completed in 1928.

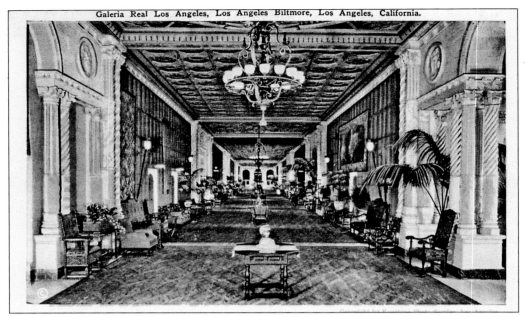

This postcard depicts the Biltmore Hotel's Galleria Real. Extending the width of the hotel, the elegant galleria provided access to many of the hotel's banquet rooms and ballrooms. The elaborate ceiling and wall murals seen here and throughout the rest of the hotel were painted by Italian muralist and renowned artist Giovanni Smeraldi.

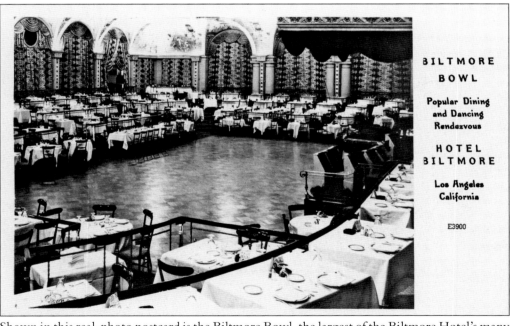

Shown in this real-photo postcard is the Biltmore Bowl, the largest of the Biltmore Hotel's many ballroom, banquet, and dining facilities. In addition to being a popular dining and dancing spot in the 1930s and 1940s, the Biltmore Bowl hosted several early Academy Award ceremonies.

Five

SHOPPING, DINING, AND ENTERTAINMENT

The Chutes, Los Angeles, Cal.

This 1908 postcard shows some of the rides at Chute's Park, Los Angeles's earliest amusement park. On the left is the figure-eight roller coaster built in 1903, and on the right is the popular Shoot the Chutes ride, in which visitors ascended a 75-foot tower and rode in boats down the ramp into the man-made lake. Located at Washington and Main Streets, at the time on the outskirts of town, the park operated under three different owners from 1887 to 1914, and was known at various points as Washington Gardens, Chutes Park, and Luna Park.

Opened in 1887, Chutes Park was popular until the late 1890s, when the park became neglected and unfrequented. When the park was purchased in 1899, it was updated with new rides and attractions. Seen here are two of the additions: the Shoot the Chutes boat ride and the Chutes Theater, where vaudeville and other shows were presented. Other attractions included a miniature railroad, a restaurant, venues for bowling, skating, and dancing, a seal pond and other animal exhibits, and a baseball diamond in the northern portion of the park.

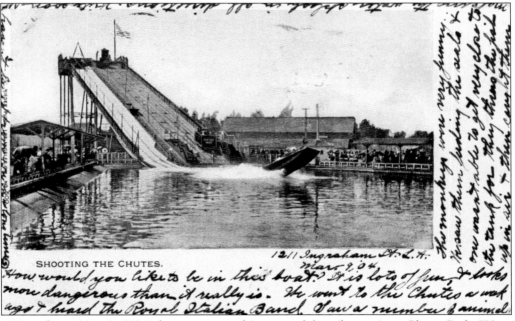

SHOOTING THE CHUTES.

Written by a visitor in 1904, the message on this postcard describes a trip to Chutes Park: "How would you like to be in this boat? It is lots of fun, and looks more dangerous than it really is. We went to the Chutes a week ago and heard the Royal Italian Band. Saw a number of animals. The monkeys were very funny. We saw them feeding the seals and one wasn't able to get very close to the tank for they throw the fish up in the air and then caught them making the water splash in all directions."

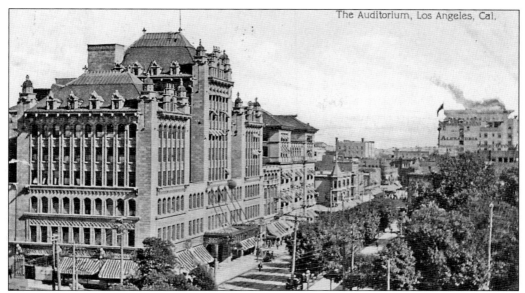

Dedicated in 1906, the Auditorium was located at Fifth and Olive Streets overlooking Central Park. From the 1880s to 1905, this site had been home to Hazard's Pavilion, an entertainment venue that hosted operas, festivals, speeches, and other gatherings. The Auditorium, the largest building in the city to have been constructed of reinforced concrete and steel, became the new venue for many of these functions. To the right of the Auditorium is the California Club headquarters, and at far right is the Hotel Alexandria, opened in 1906 at Spring and Fifth Streets.

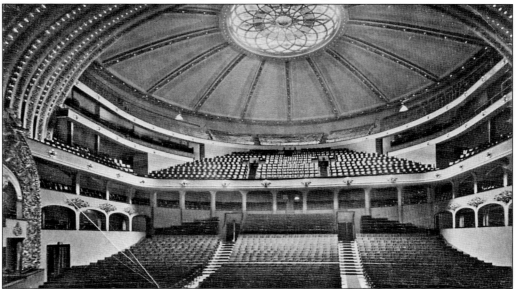

Shown here is the interior of the Auditorium, which contained one of the largest seating capacities in the city. In 1920, the Auditorium began to host the winter performances of the Los Angeles Philharmonic Orchestra. The Auditorium was also home to the Temple Baptist Church, which began to restrict use of the Auditorium to religious functions beginning in the late 1940s. However, they continued to allow the Philharmonic Orchestra to perform until the Music Center on Grand Avenue opened in 1964.

Dreamland Roller Skating Rink. Cor. 12th and Main St.
The finest and largest rink in the city.

When roller skates began to be mass produced in the 1880s, roller skating became a popular pastime. Shown in this early-1900s postcard is the Dreamland Roller Skating Rink, which was located at Twelfth and Main Streets. The postcard advertises the rink as being the finest and largest in the city.

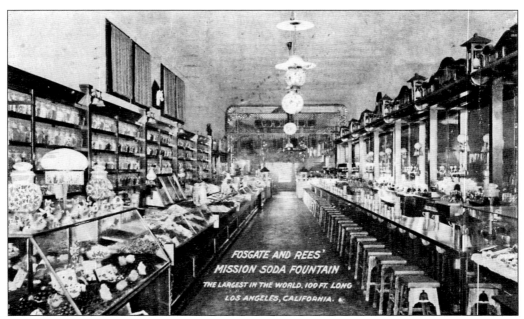

Fosgate and Rees', located on Broadway between Fourth and Fifth Streets, advertised its 100-foot-long soda fountain as being the largest in the world. Opposite the fountain counter is visible the shop's display of candy. Fosgate and Rees' also contained an ice cream parlor and a café where regular meals were served.

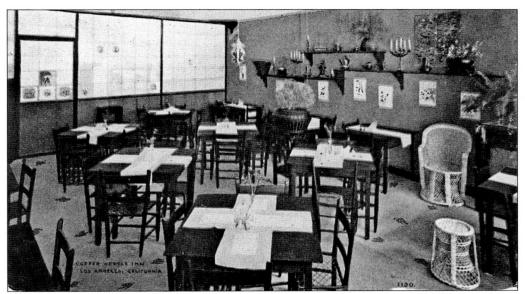

The many tearooms found downtown in the early 1900s were popular for enjoying a snack or lunch while sightseeing or shopping. Serving more than just tea, tearooms usually had menus similar to those found at small cafés. The Copper Kettle Tea Room, shown in this 1909 postcard, advertised itself as being the first tearoom in Los Angeles. The tearoom was located on Mercantile Place, an arcade of shops that ran through from Broadway to Spring Street halfway between Fifth and Sixth Streets. Mercantile Place was later the site of the Arcade Building, whose ground floor contained a similar shop-lined passageway.

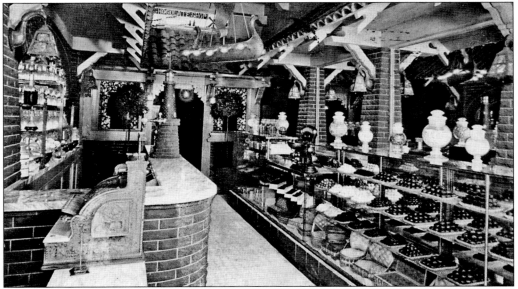

This 1911 postcard shows the Chocolate Shop, a confectionery located on Fifth Street. Just across from the Hotel Alexandria, the shop was popular among hotel guests. Chocolate shops such as this one frequently contained cafés where meals could be ordered. Serving as popular meeting places for shoppers, theater attendees, and tourists, chocolate shops were usually crowded at lunchtime and in the evening, after theater and entertainment events had ended.

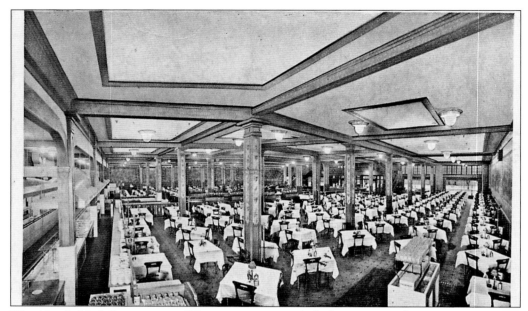

The idea behind "serve yourself" restaurants, popularly known as cafeterias, is reputed to have originated in Los Angeles. By the 1920s, cafeterias were a common sight throughout the downtown area. The large cafeteria shown here, B&M Cafeteria, was located on Hill Street opposite Central Park.

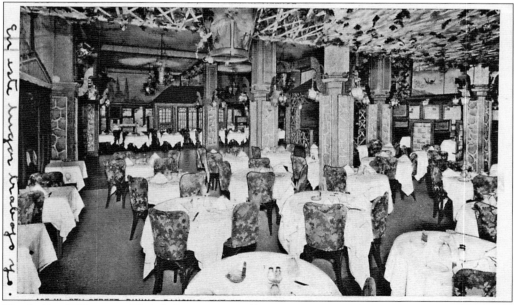

The Italian Village, on Eighth Street near Hill Street, was one of the many restaurants in the city to provide music and entertainment as part of the dining experience. The restaurant's advertisement on the reverse of this 1933 postcard boasts, "Dine and be merry. You can do both here, noon and evening: This is proven by the hundreds who visit us daily; many come day in and day out. You'll like it—the food and atmosphere is DIFFERENT—a dinner with us and a few dances will drive care away."

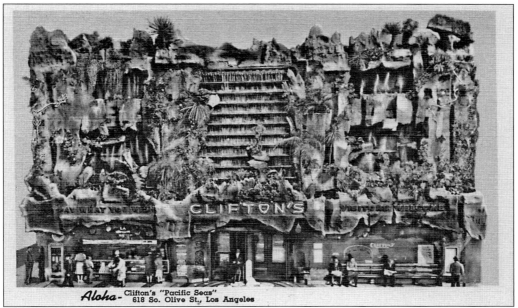

Aloha - Clifton's "Pacific Seas"
618 So. Olive St., Los Angeles

In 1931, Clifford Clinton sold his share in a chain of cafeterias in San Francisco and moved to Los Angeles to open a new cafeteria. Basing his business on the slogan "Pay what you wish or dine free unless delighted," Clinton opened the first Clifton's Cafeteria on Olive Street, known as Pacific Seas. Clinton remodeled the facade, seen above, with a tropical theme, complete with a waterfall. The interior, seen below, featured tropical scenery, waterfalls, and a rain hut where it rained every 20 minutes. Diners were presented with Hawaiian leis and entertained with organ music and live performances. The restaurant also hosted a hospitality service desk, where visitors could obtain tourist information and arrange to go on the 15¢ sightseeing tour that departed from the cafeteria hourly.

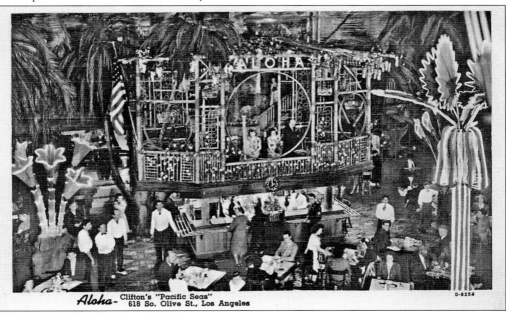

Aloha - Clifton's "Pacific Seas"
618 So. Olive St., Los Angeles

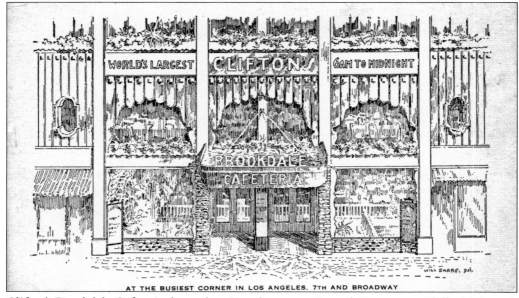

Clifton's Brookdale Cafeteria, located on Broadway near Seventh Street, was Clifford Clinton's second Los Angeles cafeteria, opened in 1935. The elaborate themed decor of both the Brookdale and Pacific Seas cafeterias made them favorite tourist destinations and popular local dining spots. Feeling a responsibility to the community, Clinton provided thousands of free and low-cost meals during the Depression under his policy, "No guest shall go hungry for lack of funds."

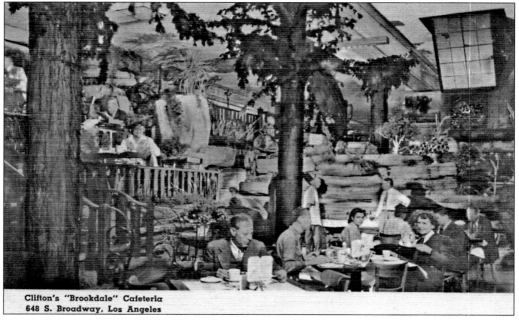

Clifton's "Brookdale" Cafeteria
648 S. Broadway, Los Angeles

Shown here is the interior of Clifton's Brookdale Cafeteria. Meant to re-create a woodland scene, the interior featured terraced dining among redwood groves, rock sculptures, waterfalls, a running brook, caves, and a wishing well. While Clifton's Pacific Seas closed in 1960, the Brookdale Cafeteria is still a downtown favorite.

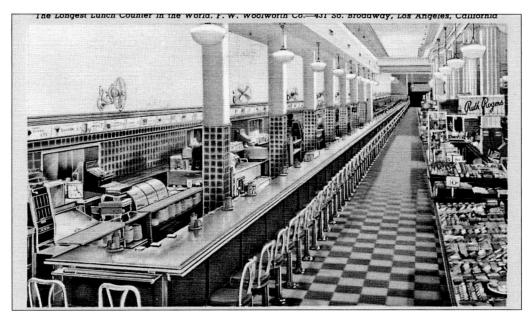

This postcard depicts the lunch counter of the popular five-and-dime store Woolworth's, located on Broadway near Fourth Street. The store advertised the lunch counter as being the longest in the world, measuring 100 yards long. Visible on the right is some of the store's merchandise, laid out for customers to handle. This layout was a sharp contrast to most stores at the time, which kept their merchandise in display cases. The store was part of the successful Woolworth's retail chain, founded in New York in 1878.

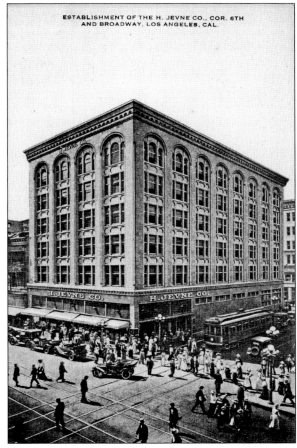

ESTABLISHMENT OF THE H. JEVNE CO., COR. 6TH AND BROADWAY, LOS ANGELES, CAL.

H. Jevne Company, founded by Hans Jevne in 1882, was one of the finest and best-stocked grocery stores in the West. In addition to retail shopping at their downtown locations, H. Jevne Company offered home delivery and mail-order services. The store occupied all six floors of the building shown here at Broadway and Sixth Street, opened in 1907. The company also maintained a store at Spring and Second Streets, operated since 1896. The store ceased to exist only a few years after Jevne's death in 1927.

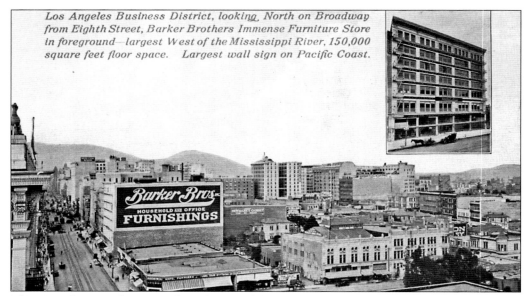

Los Angeles Business District, looking North on Broadway from Eighth Street, Barker Brothers Immense Furniture Store in foreground—largest West of the Mississippi River, 150,000 square feet floor space. Largest wall sign on Pacific Coast.

This view faces north on Broadway from Eighth Street, showing the Barker Brothers Furniture Store. Advertised as being the largest west of the Mississippi River, the store originated as O. T. Barker and Sons, a furniture store founded by Obadiah Barker in 1880. Later operated by his sons, the name was officially changed to Barker Brothers in 1898. The store relocated in 1909 from the Van Nuys Building at Spring and Seventh Streets to the building pictured here.

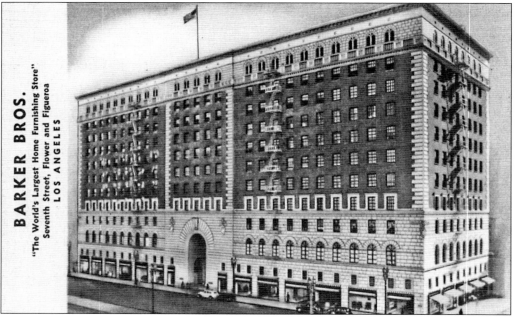

The city's largest furniture store, Barker Brothers moved to its new quarters, shown here, in 1925. Located on Seventh Street between Flower and Figueroa Streets, the store contributed to the growth of the new Seventh Street shopping district pioneered by Robinson's Department Store in 1914. More than just a furniture store, the new building contained an auditorium for events, a lobby with a pipe organ, and the Mary Louise Tearoom.

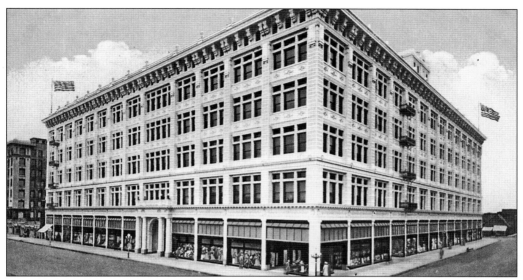

Hamburger's Department Store became the largest department store west of Chicago when its new store at Broadway and Eighth Street opened in 1908. The store dates to 1881, when Asher Hamburger opened a small shop on Spring Street known as the People's Store. The new department store housed the volumes of the Los Angeles Public Library from 1908 to 1914. In 1923, the store was acquired by the May Department Stores Company, founded in 1910, and renamed the May Company.

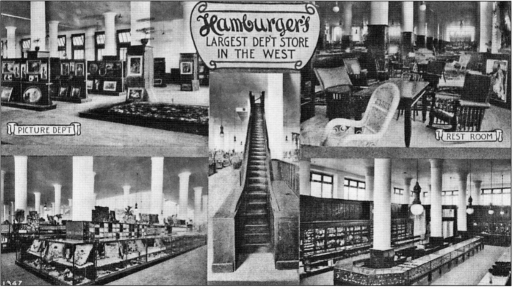

Pictured here are some of the sights at Hamburger's Department Store, including the picture department, the rest room, the art department, the jewelry, silverware, and clocks department, and the escalator. A great novelty to the 80,000 visitors who attended the store's grand opening in 1908, the escalator was the first in the city. Demonstrating this enthusiasm, the message written on the back of this postcard, mailed in 1908, makes no mention of the store itself but only describes the escalator. The giant store also contained parlors, reading rooms, an auditorium, a nursery, and a restaurant.

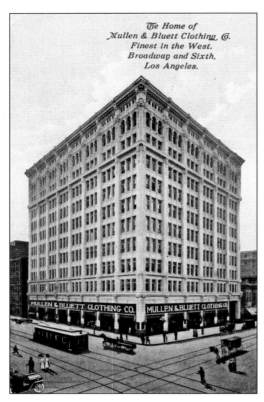

The Home of
Mullen & Bluett Clothing Co.
Finest in the West.
Broadway and Sixth,
Los Angeles.

Postmarked in 1911, this postcard depicts Mullen and Bluett department store, a high-end clothing store founded in 1889 by William Bluett and Andrew Mullen. Previously located at Spring and First Streets, the store had since 1910 operated from the bottom two floors of the Walter P. Story Building at Broadway and Sixth Street.

Blackstone's Dry Goods Store was founded in 1895 by Nathaniel Blackstone, who had once worked for his brother-in-law J. W. Robinson at his store, Boston Dry Goods, later known as Robinson's Department Store. Moving from smaller quarters on Broadway between Third and Fourth Streets, the new Blackstone's store opened at the location shown here at Broadway and Eighth Street in 1917.

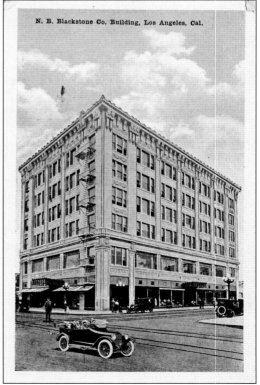

N. B. Blackstone Co. Building, Los Angeles, Cal.

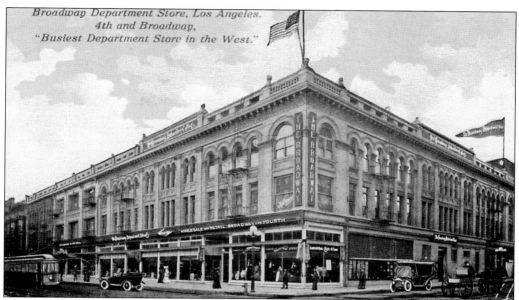

The Broadway Department Store, founded by Arthur Letts in 1896, was designed to appeal to those of a median income range. The store experienced almost immediate success despite its location at Broadway and Fourth Street, at the time considered somewhat far from the business center. The store became more central over the next few years as the business district crept south, allowing Letts to expand by purchasing adjoining buildings. In 1907, Letts built an all-new structure, located on the same site as the earlier store.

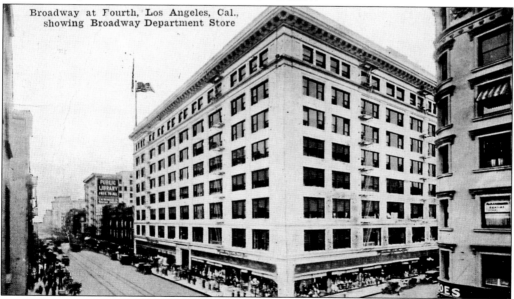

Postmarked in 1916, this postcard depicts the larger store completed in 1914 to house the Broadway Department Store, located on the site of the smaller store in the previous image. The new store demonstrated the truth of the store's long-held motto, "Watch us Grow." In the distance on Broadway is visible a sign advertising the public library, which operated from that site in the Metropolitan Building from 1914 to 1926.

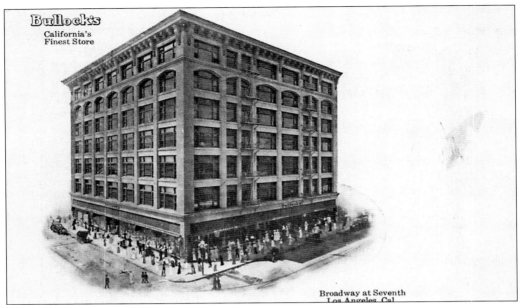

Bullock's
California's
Finest Store

Broadway at Seventh
Los Angeles, Cal.

Bullock's Department Store originated when Broadway Department Store owner Arthur Letts was asked to open a second Broadway store in a new building at Broadway and Seventh Street. Opting against a second branch, Letts decided instead to approach favorite Broadway employee John Bullock about founding an entirely new store. While Letts provided the opening capital, Bullock was allowed to give the store his name. Designed to appeal to a more affluent clientele than the one served by the Broadway store, the new Bullock's Department Store opened in 1907.

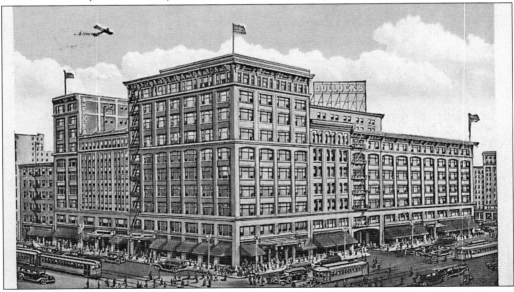

This postcard, dated 1935, shows the new 10-story addition to Bullock's Department Store at Hill and Seventh Street. As Bullock's had become one of the most successful department stores, it expanded until it eventually occupied the entire block on Seventh Street, stretching from Broadway to Hill Street. The intersection at Broadway and Seventh Street had by the time of this image become the busiest section of the downtown shopping district.

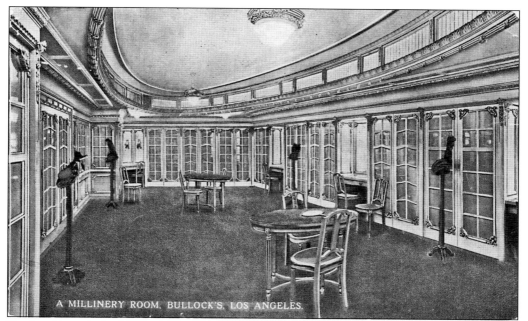

A MILLINERY ROOM, BULLOCK'S, LOS ANGELES.

Depicted here is the Millinery Room in Bullock's Department Store. Containing departments for almost any apparel or household item a shopper could wish for, Bullock's was one of the busiest department stores. In 1923, following the death of Arthur Letts, John Bullock was able to buy out Letts's interest in the store, giving him complete independence from its previous ties to the Broadway Department Store.

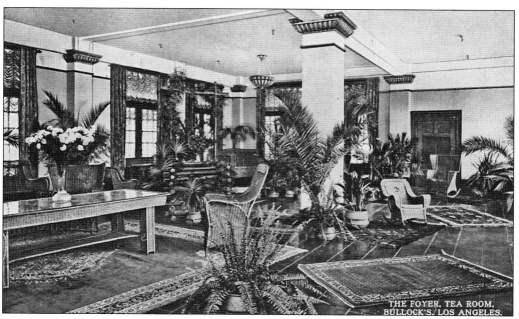

THE FOYER, TEA ROOM, BULLOCK'S, LOS ANGELES.

This postcard portrays the foyer of the Bullock's Tea Room. Designed for the convenience and comfort of its guests, the tearoom allowed shoppers to take a break from shopping and enjoy a cup of tea or a light meal.

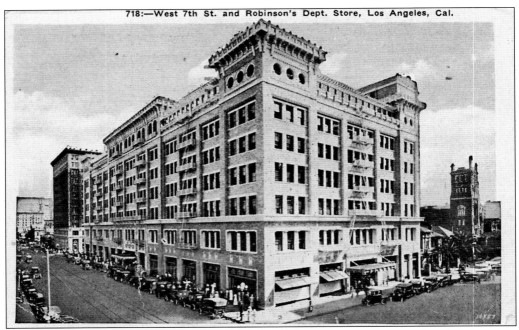

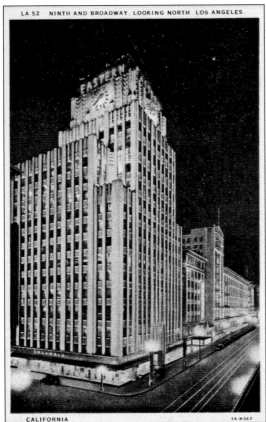

LA 52 NINTH AND BROADWAY. LOOKING NORTH. LOS ANGELES.

CALIFORNIA 1A-H367

In 1883, J. W. Robinson founded Boston Dry Goods, a small store located at Spring and Temple Streets. Later known as Robinson's Department Store, the successful store relocated in 1914 to the building seen here. Located on Seventh Street between Grand and Hope Streets, this spot was once occupied by the city's post office before a new post office structure was built at Main and Temple Streets in 1908. As the first major store in the area, Robinson's helped establish a new retail district on Seventh Street.

Shown here is the Eastern Columbia Building, opened by Adolph Siertoy as the headquarters of his two stores. His first store, the Eastern Outfitting Company, originated in the 1890s as the Eastern Clock Company, gradually expanding to carry almost any item for the home. In 1912, Siertoy founded a second store, the Columbia Outfitting Company, in order to expand into the clothing business. The two stores were united when the new building opened at Broadway and Ninth Street in 1930. A striking example of art deco architecture designed by Claud Beelman, the 13-story Eastern Columbia Building features a facade of turquoise terra-cotta trimmed with gold.

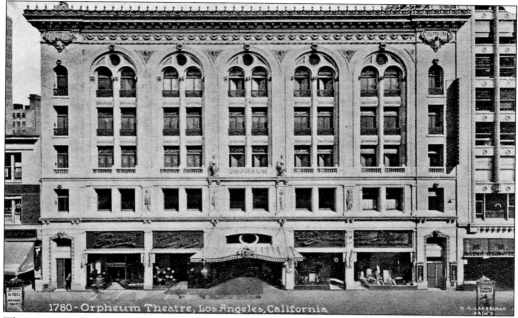

1780 - Orpheum Theatre, Los Angeles, California

These postcards depict the exterior and interior of the Orpheum Theater, opened in 1911 as the third home of the popular Orpheum vaudeville circuit. Located on Broadway between Fourth and Fifth Streets, the theater hosted some of the most famous performers of the day. In 1911, when the Orpheum moved to this theater, the theater district was still concentrated on Main and Spring Streets. Together with the Pantages Theater that had opened on Broadway in 1910, the Orpheum Theater helped spur the westward shift of the theater district to Broadway. In 1926, the Orpheum circuit moved to a fourth home, a newly constructed theater on Broadway between Eighth and Ninth Streets. The vacated theater became a movie house called the Palace. With the shift to film, the box seating seen below was removed and replaced with murals.

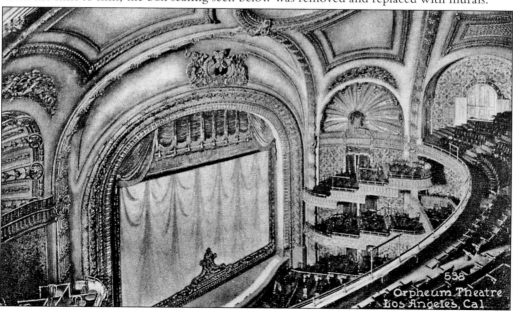

Orpheum Theatre
Los Angeles, Cal.

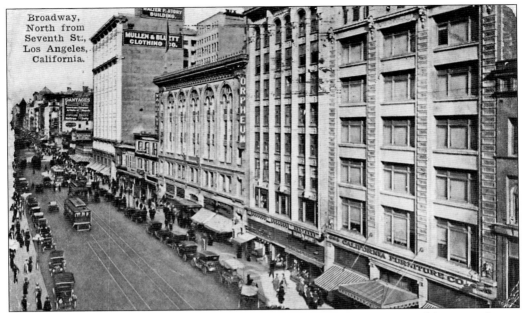

Broadway, North from Seventh St., Los Angeles, California.

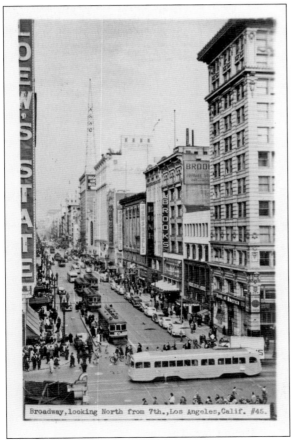

Broadway, looking North from 7th., Los Angeles, Calif. #45.

Postmarked in 1916, this postcard provides a view of Broadway looking north from Seventh Street. Visible is Mullen and Bluett Clothing Company, located in the Walter P. Story Building since 1910. Also visible are two of the earliest theaters on Broadway: the Orpheum, at the middle of the image, and the Pantages, seen in the distance. Both vaudeville circuits would soon relocate, and the two theaters seen here were converted to movie houses.

This real-photo postcard shows a later scene from the same viewpoint as the previous image, facing north on Broadway from Seventh Street. At left is the sign for Loew's State Theater, which had opened in 1921. Mullen and Bluett is still visible in the Walter P. Story Building, although the old Orpheum Theater now advertises newsreels instead of vaudeville. The view of the Pantages Theater, now a movie house named the Arcade Theater, has been obscured by the 1924 Arcade Building, seen here topped by a radio tower.

The Hill Street Theater was constructed by the Orpheum vaudeville circuit in 1922 at Hill and Eighth Streets. Known as the Junior Orpheum, the theater served as a secondary performance space for the circuit, whose main theater was located on Broadway. While the main theater presented two shows per day with the best headlining acts, the Junior Orpheum offered lower-priced continuous performances, alternating vaudeville with movies. The Hill Street Theater began showing movies as the RKO Theater in 1929.

715:—Hill St. Theatre, Junior Orpheum, Los Angeles, Cal.

LA-112. SEVENTH STREET WEST FROM HILL.

LOS ANGELES, CALIFORNIA. 101308

Part of a circuit of vaudeville theaters owned by Alexander Pantages, the Pantages Theater opened at Hill and Seventh Streets in 1920. Replacing the earlier Pantages Theater on Broadway between Fifth and Sixth Streets, the new theater was designed to showcase both vaudeville and motion pictures. After Pantages sold his theater chain in 1929, this theater was renamed the Warner Downtown Theater.

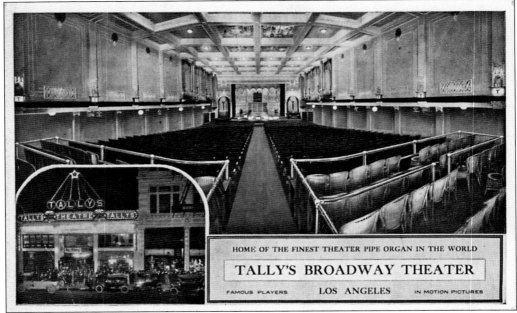

HOME OF THE FINEST THEATER PIPE ORGAN IN THE WORLD

TALLY'S BROADWAY THEATER

FAMOUS PLAYERS LOS ANGELES IN MOTION PICTURES

Shown here is Tally's Broadway Theater, opened by Thomas Tally in 1910. Seating about 900 people, the movie house was located on Broadway between Eighth and Ninth Streets, adjacent to Hamburger's Department Store. A few years after Hamburger's was sold to the May Company in 1923, the theater was demolished for a 1929 May Company extension.

Souvenir

FERRIS HARTMAN'S
GRAND OPERA HOUSE

FERRIS HARTMAN

AND HIS SUPERB COMPANY IN

THE CAMPUS

A MUSICAL COMEDY OF COLLEGE LIFE
BY WALTER DE LEON

Walter De Leon as "Bobby Short" "Muggins" Davies as "Nellie Perkins"

I saw the --Performance

It was on --1911

I was with ---

And the show was---

--

--

LOS ANGELES. CAL.

This postcard is a souvenir of the 1911 production of *The Campus*, a musical comedy that appeared at one of the city's early legitimate theaters, the Grand Opera House. Located on Main Street near First Street, the theater was the second largest on the Pacific coast in 1884, when it was built by Ozro Childs. By the 1890s, legitimate theater began to be surpassed by vaudeville in popularity.

The Million Dollar Theater, located
at Broadway and Third Street, was
opened by Sid Grauman in 1918.
Seating over 2,000 people on two
levels, the theater was designed
as a movie palace, although it
also contained a full stage. The
theater was the first of several to be
constructed by Grauman in the Los
Angeles area. In 1923, he opened the
Metropolitan Theater downtown, and
in Hollywood, he built the Egyptian
Theater in 1922 and the Chinese
Theater in 1927.

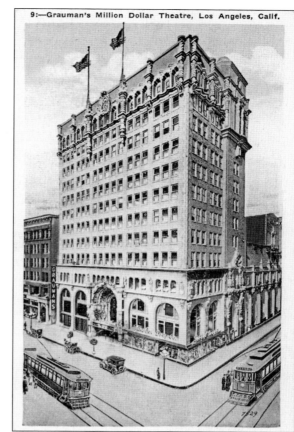

9:—Grauman's Million Dollar Theatre, Los Angeles, Calif.

Grauman's Metropolitan Theater,
which opened in 1923, was the second
downtown theater constructed by Sid
Grauman. The largest in the city with
3,600 seats, the theater was located at
Hill and Sixth Streets, overlooking
Pershing Square from the former
site of the First Methodist Episcopal
Church. Later acquired by Paramount
Pictures, the theater was renamed
Paramount Downtown in 1929. It was
demolished in 1963.

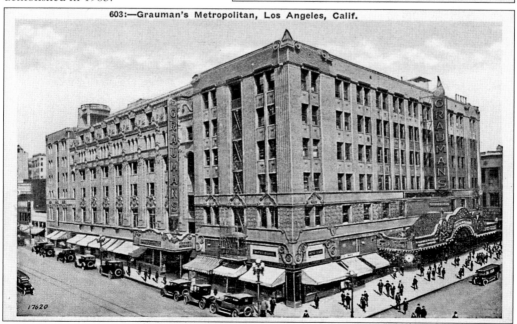

603:—Grauman's Metropolitan, Los Angeles, Calif.

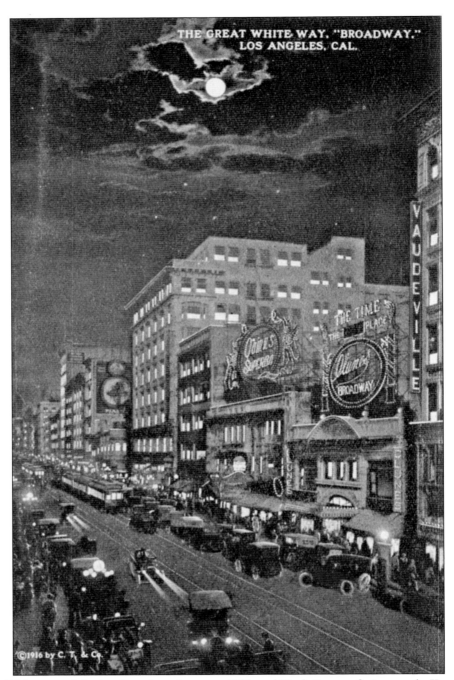

This 1916 postcard depicts Broadway between Fifth and Sixth Streets, facing north. Known as the Great White Way because of the large number of illuminated signs, Broadway had by this time replaced Main Street as the city's theater district. At right are two movie theaters, Quinn's Superba, opened in 1914, and Clune's Broadway, opened in 1910. The vaudeville sign belongs to the Pantages Theater, which later became a movie theater after the Pantages vaudeville circuit moved to a new theater at Hill and Seventh Street in 1920.

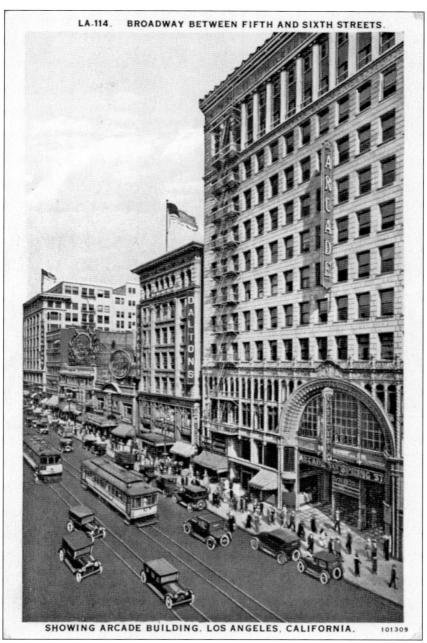

SHOWING ARCADE BUILDING, LOS ANGELES, CALIFORNIA. 101309

This 1920s postcard shows a similar view, facing north on Broadway from Sixth Street, about 10 years later. In this image, Quinn's Superba is occupied by Talt's Coffee Shop, which opened in 1923. In 1931, the theater building would be demolished and replaced by the Roxie Theater. Clune's Broadway, still a movie house, has been renamed the Cameo Theater. The Pantages Theater has here become a movie theater named Dalton's. Called Dalton's for only eight years, the theater was renamed the Arcade Theater in 1928 in honor of its neighbor, the Arcade Building. Opened in 1924 on the site of an earlier shopping passageway known as Mercantile Place, the Arcade Building's ground level featured a shop-lined arcade that continued through to Spring Street.

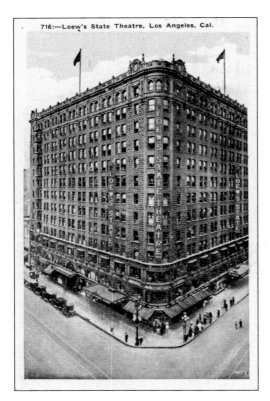

716:—Loew's State Theatre, Los Angeles, Cal.

Loew's State Theater opened in 1921 as part of a movie theater chain owned by Marcus Loew. The largest on Broadway, the theater was immediately successful as a result of its location at Broadway and Seventh Street, one of the city's busiest intersections. In addition to owning a national series of theaters, Loew was responsible for the foundation of Metro-Goldwyn-Mayer (MGM) in 1924, when he merged his recent acquisitions, Metro Pictures Corporation and Goldwyn Picture Corporation, with a film production company purchased from Louis Mayer.

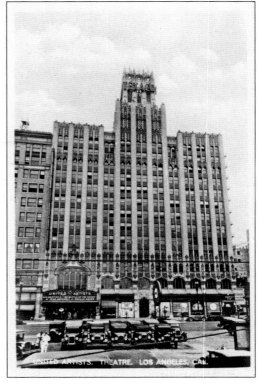

The United Artists Theater opened in 1927 at Broadway and Ninth Street. Seeking independence from the studios, United Artists had been formed in 1919 by D. W. Griffith, Charles Chaplin, Mary Pickford, and Douglas Fairbanks. Showing at the theater in this image is D. W. Griffith's 1928 film *Battle of the Sexes*, starring Jean Hersholt and Phyllis Hayer.

124

This view faces north along Broadway from Eighth Street, with the Morosco Theater visible on the right. This legitimate theater was opened in 1913 for Oliver Morosco, the manager of a popular stock company. The building was designed by Morgan and Walls, who had also designed the Pantages Theater and the Walter P. Story Building, both visible in the distance. As was the case with most live theaters, the Morosco Theater had by the end of the 1920s begun showing movies. Known first as the President Theater, by the end of the 1940s, the theater had been renamed the Globe.

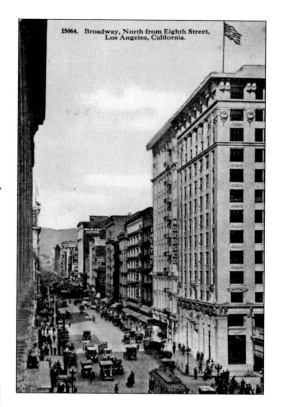

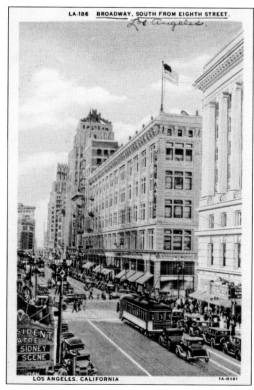

This 1931 postcard faces south on Broadway from Eighth Street. On the right are two major retailers: the May Company and the Eastern Columbia Building. In the distance beyond the Eastern Columbia Building, where the Texaco sign appears, is the United Artists Theater. In the left foreground is the President Theater, formerly the Morosco. A movie house since the late 1920s, the marquee here advertises the 1931 film *Street Scene*, starring Sylvia Sidney. Across the street is the Broadway entrance to Bard's Eighth Street Theater. Opened in 1927, Bard's was renamed the Olympic Theater in 1932.

125

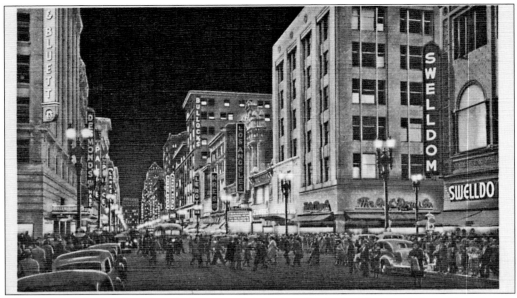

This postcard depicts Broadway's theater and shopping district looking south from Sixth Street. Several popular retailers are visible, including Mullen and Bluett and Desmond's on the left, and Swelldom, Bullock's, and the Eastern Columbia Department Store on the right. Three theaters are also in sight. On the left is the Palace, formerly the Orpheum Theater. On the right is Loew's State Theater and the Los Angeles Theater, which was completed in 1931 as the most elaborate movie palace on Broadway.

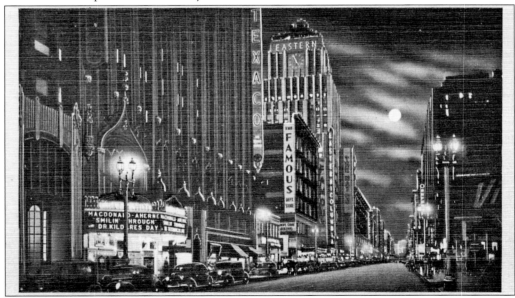

Looking north on Broadway toward Ninth Street, this postcard shows another part of the busy shopping and theater district on Broadway. The Eastern Columbia Building towers over the left side of the street. Directly across is the 1926 Orpheum Theater, which had become a movie house by the time of this image. In the left foreground is the marquee of the United Artists Theater, advertising the 1941 film *Smilin' Through*, starring Jeannette MacDonald.

BIBLIOGRAPHY

Forbes, A. S. C. *Then and Now: 100 Landmarks within 50 Miles of Los Angeles Civic Center*. Los Angeles: Board of Supervisors of Los Angeles, 1939.

Grenier, Judson, ed. *A Guide to Historic Places in Los Angeles County*. Dubuque, IA: Kendall/Hunt Publishing Company, 1978.

Guinn, James. *A History of California and an Extended History of Los Angeles and Environs*. Los Angeles: Historic Record Company, 1915.

Hill, Laurance. *La Reina: Los Angeles in Three Centuries*. Los Angeles: Security Trust and Savings Bank, 1929.

History Division of the Los Angeles County Museum. *Los Angeles 1900–1961*. Los Angeles: History Division of the Los Angeles County Museum, 1962.

Mackey, Margaret. *Los Angeles Proper and Improper*. Los Angeles: Goodwin Press, 1938.

McGroarty, John. *Los Angeles from the Mountains to the Sea*. Chicago: American Historical Society, 1921.

Nadeau, Remi. *City-Makers*. Garden City, NY: Doubleday and Company, 1948.

Newmark, Harris. *Sixty Years in Southern California 1853–1913*. New York: The Knickerbocker Press, 1926.

Philips, Alice. *Los Angeles: A Guide Book*. Los Angeles: The Neuner Company, 1907.

Robinson, W. W. *The Story of Pershing Square*. Los Angeles: Title Guarantee and Trust Company, 1931.

Taylor, Katherine. *The Los Angeles Tripbook*. New York: The Knickerbocker Press, 1928.

Weaver, John. *Los Angeles: The Enormous Village*. Santa Barbara, CA: Capra Press, 1980.

Workers of the Writer's Program of the Works Project Administration. *Los Angeles: A Guide to the City and Its Environs*. New York: Hastings House, 1951.

Young, Betty Lou. *Our First Century: The Los Angeles Athletic Club 1880–1980*. Los Angeles,: LAAC Press, 1979.

Across America, People are Discovering Something Wonderful. *Their Heritage.*

Arcadia Publishing is the leading local history publisher in the United States. With more than 4,000 titles in print and hundreds of new titles released every year, Arcadia has extensive specialized experience chronicling the history of communities and celebrating America's hidden stories, bringing to life the people, places, and events from the past. To discover the history of other communities across the nation, please visit:

www.arcadiapublishing.com

Customized search tools allow you to find regional history books about the town where you grew up, the cities where your friends and family live, the town where your parents met, or even that retirement spot you've been dreaming about.